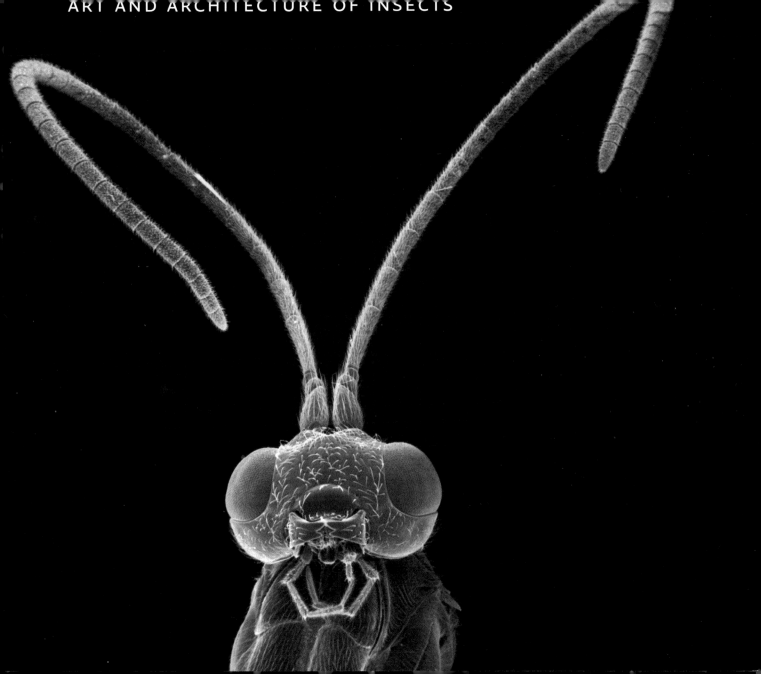

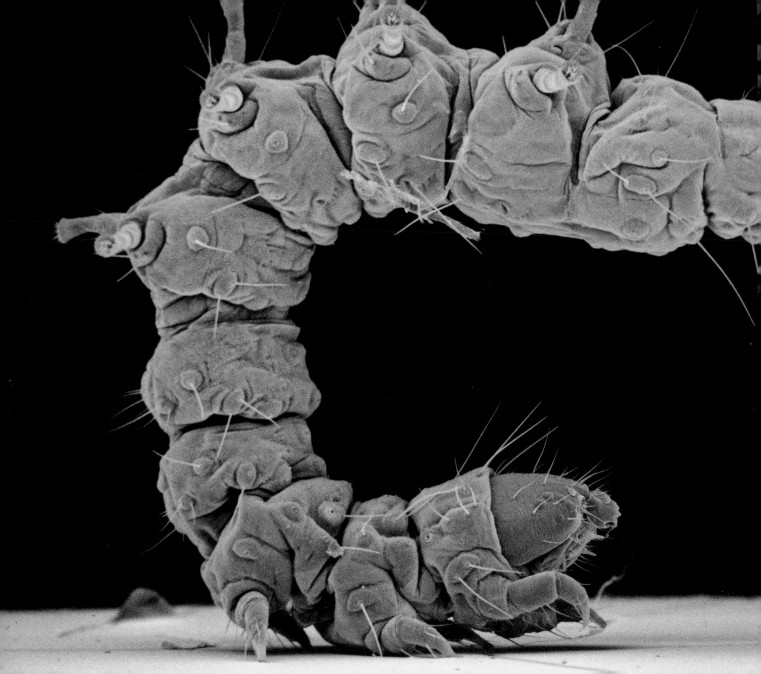

publication of this book is supported by a grant from FIGURE FOUNDATION

DAVID M. PHILLIPS

art and architecture of insects

ForeEdge

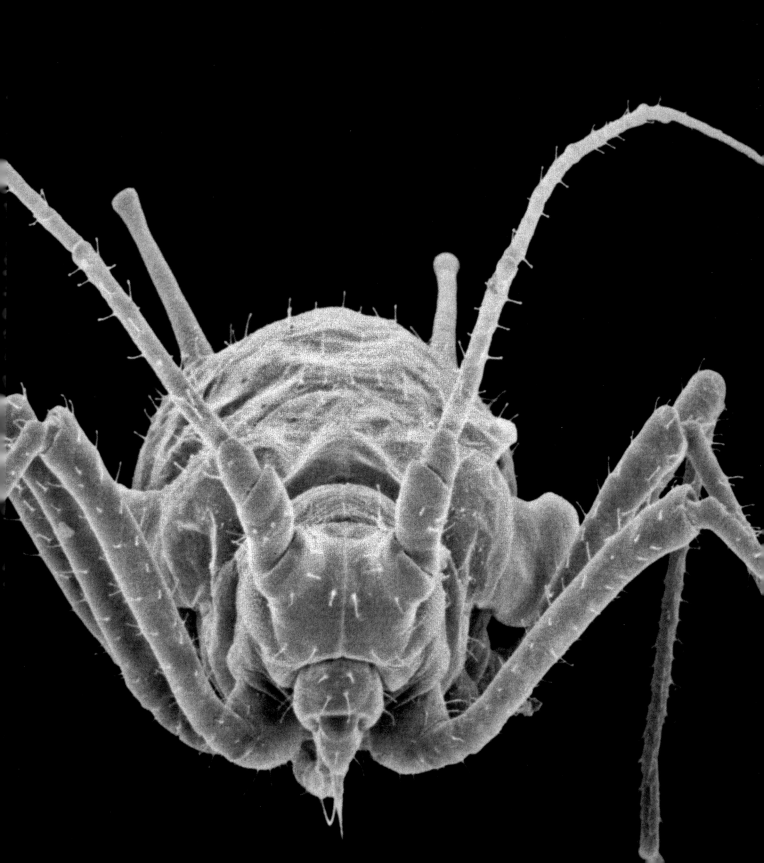

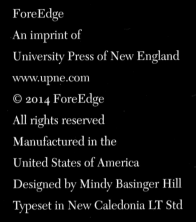

ForeEdge
An imprint of
University Press of New England
www.upne.com
© 2014 ForeEdge
All rights reserved
Manufactured in the
United States of America
Designed by Mindy Basinger Hill
Typeset in New Caledonia LT Std

Library of Congress
Cataloging-in-Publication Data

Phillips, David M.
Art and architecture of insects / David M.
Phillips.
 pages cm
ISBN 978-1-61168-532-9 (pbk. : alk. paper)
1. Insects—Anatomy. 2. Insects—
Anatomy—Pictorial works. 3. Electron
microscopy. I. Title.
QL494.P45 2014
595.7—dc23 2013030212

5 4 3 2 1

CONTENTS

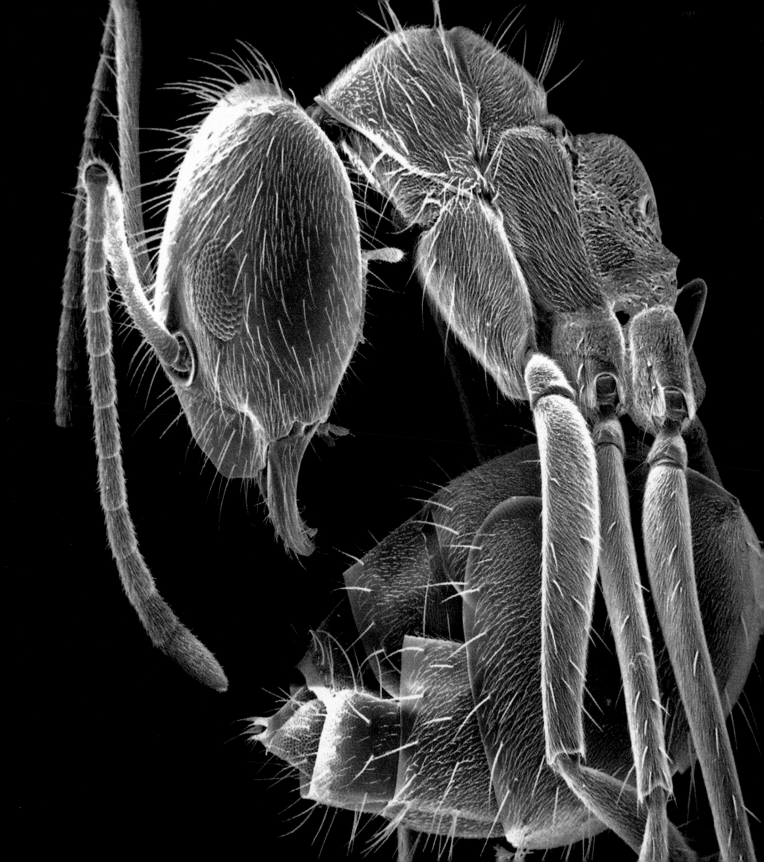

PREFACE

From the time I was a young child I have been captivated by insects, learning about them while roaming the woods, fields, and streams in or near my childhood town of Newton, Massachusetts. In my early teens I enrolled in my first insect course, Junior Entomologists, given by the Museum of Science in Boston. There I learned how to identify, name, label, and mount insects, producing a conventional insect collection. This collection continued to grow throughout my high school and college years at Northeastern University until, unfortunately, it was consumed by carpet beetle larvae, which at the time I didn't realize were stowaways in the collection.

While in graduate school at the University of Chicago I was introduced to the electron microscope during a Cell Biology course — an instrument with powers of magnification and resolution thousands of times greater than optical microscopes. I was immediately enthralled by the details this kind of instrument revealed. So much so that I used electron microscopes over the next fifty years of my remaining academic research and professional career, beginning with research for my graduate thesis on the structures involved in the motility of the spermatozoa of a fly, followed by a postdoctoral fellowship at Harvard Medical School doing a comparative study of the sperm from different insects. All the while I was learning more about insect identification and the best places in which to find them. This was great. I would collect insects at Harvard's Arnold Arboretum, which I loved to do, and get paid.

When I established my own laboratory, it became difficult to obtain research grants for such esoteric subjects as insect sperm, so instead I focused

my research on mammalian sperm and its role in fertilization, which was fundable. By the early 1980s—after HIV, the causative agent (virus) of AIDS, was described—I once again changed the focus of my research. Given the front-page attention that HIV was getting, I was all too aware of the devastating hardships caused by this virus and the ensuing pandemic. My background in reproduction biology lent itself fairly well to better understanding the mechanisms of the sexual transmission of HIV; thus I dedicated the remaining twenty-some years of my career to conducting research on virology, HIV, AIDS, other sexually transmitted infections, and prevention strategies.

However, I never gave up my avocation of insects. In my spare time I would collect insects anywhere I happened to be, bring them to the laboratory to examine, and prepare them for photographing in the scanning electron microscope. The hard exoskeleton of insects renders them especially suitable subjects for this kind of microscope, because it helps to prevent them from becoming distorted by the procedures they must undergo in preparation for scanning with an electron beam.

The process begins with collecting the insects. I use a sweep net with a plastic vial at the bottom. With a dozen or so sweeps several hundred insects may be caught, although most are visible only as very tiny specks. Larger insects are set free, as they are too big to fit into the microscope's scanning chamber. The catch is immediately placed in a small bottle containing 95 percent ethyl alcohol, which prevents them from drying out and becoming too brittle for further processing. Back in the lab, the insect and alcohol are placed in a shallow dish and examined using a dissecting microscope. I look through hundreds of insects in order to find a few good specimens. Those that are suitable are transferred to a more dilute solution of alcohol that makes them pliable enough to adjust the position of their legs, wings, and antennae into life-like poses. This requires the use of the dissecting microscope and the finest forceps, along with steady hands and dexterity. It is a very time-consuming, tedious job. Sometimes, when I had the insect in the perfect position, a slip of my hand would cause a leg or antenna to break off, ruining the specimen. This always seemed to happen with the rarest of insects. Once positioned, the insect is transferred onto filter paper to dry for a few minutes, after which it can be mounted on a metal specimen stud.

Because the scanning electron microscope produces a surface image of a specimen by use of a focused beam of electrons, the surface of the specimen must be made electrically conductive. To accomplish this, the insect is covered with a very thin and even coating of gold. The gold is applied by an instrument called a sputter coater, which employs an electric field and argon gas to deposit atomized gold on the specimen inside a coating chamber under partial vacuum.

Once the insect is coated with gold, it is ready for viewing in the microscope's specimen chamber. Because electrons rather than light produce an image, the scanning, too, is done under vacuum. In addition to its high resolving power, the scanning electron microscope has several other advantages over a traditional microscope. One advantage is that it has what is called dynamic focus, which allows the more distant as well as the closest parts of the specimen to be in focus at the same time. Furthermore, the microscope in my laboratory had the unique ability to rotate the specimen 90 degrees. As the electron beam was directed downward onto the top of the specimen, I was able to tip and rotate the specimen to capture images of the insects from a frontal or sideward view.

At the time I took the micrographs you will see on the following pages, the world had not yet become so digitized. My images were created as black-and-white negatives on film that I then had to process in a darkroom, in the same way that photographic film used in optical cameras had to be developed and images printed from the film negatives. In some publications, color is added to electron micrographs using computer software. Small insects are typically drab, however, and their natural colors difficult to represent accurately. In fact, authors almost never attempt to reproduce actual coloration. Instead, artists color the images using esthetically pleasing combinations. I have chosen to render these micrographs in their original black and white and hope readers will find the images both interesting and striking.

For many years all this was a labor of love. Upon retirement I finally felt I had the time to compile the many micrographs I had made into a book that would illustrate the beautiful art and rich architecture of insects. It is my hope that you will enjoy these micrographs and, especially, be impressed by the beauty and complexity of these fantastic little animals.

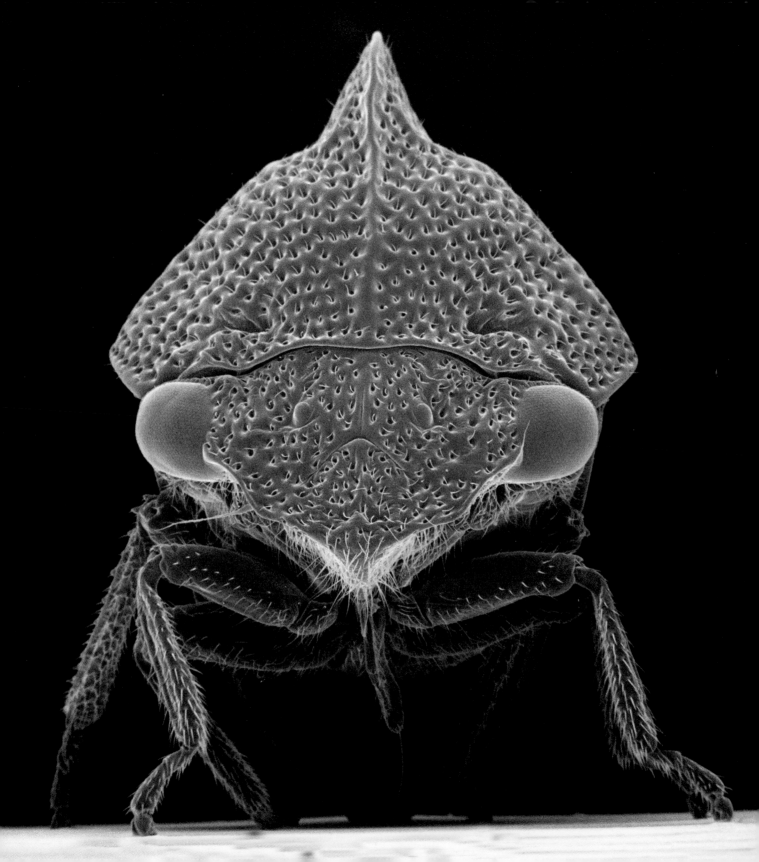

ACKNOWLEDGMENTS

I want to thank Mr. Ken Converse, an outstanding engineer who, over the years, has modified my scanning electron microscope and taught me how to get the most out of it. I am also grateful to my brother Walter, who has patiently taught me the ins and outs of photography and Photoshop. Lastly, I want to thank my wife, Robin Maguire, for her help with writing, her many helpful suggestions, and for her encouragement and understanding.

ART AND ARCHITECTURE OF INSECTS

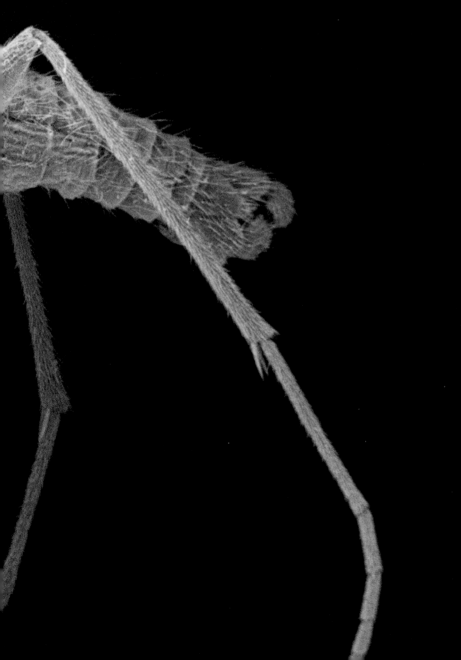

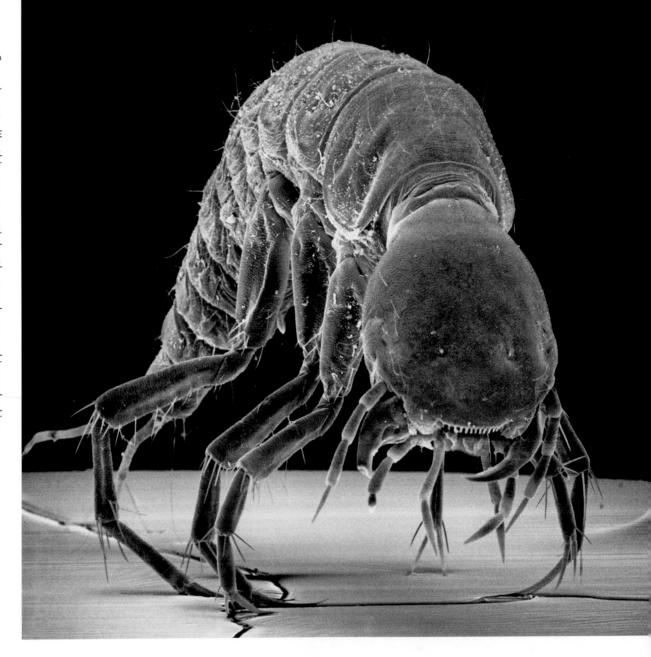

Some insects, like this scary aquatic beetle nymph, are so bizarre-looking that many people would not know they are insects.

1 | introduction

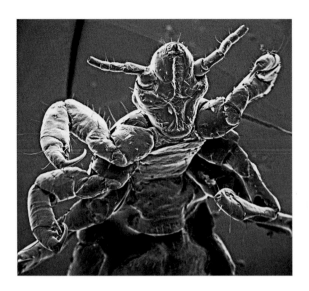
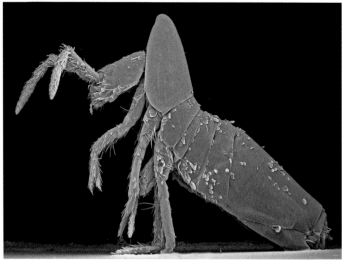

INSECTS belong to a group of animals called arthropods, which also includes spiders, mites, scorpions, crabs, lobsters, and shrimp, as well as a number of other animals that most people are not familiar with. Arthropods are characterized by an external skeleton, or exoskeleton, which is segmented such that individual segments can articulate on one another, something like the links of a flexible metal watchband. Adult insects have six legs and are unique in being the only invertebrate animals that have wings.

Insects can be found everywhere on earth except at the North Pole and in the sea. About a million species have been identified, more than all the known species of plants and other animals combined. Remarkably, it is believed that a few million more insect species exist, but to date they have not yet been described. Unfortunately, at the rate that mankind is destroying their habitats, most of these species are likely to become extinct before they can be characterized.

Insects have evolved a myriad of diverse forms that thrive in an array of different environments. Some species are so bizarre-looking that only an expert could recognize them as insects. It is this diversity in form—as well as how different types of insects use their legs and wings, how they reproduce, what they do to survive, and how they impact on humans—that fascinates those of us who study them.

LEFT My grandchildren, who are expert on monsters and the like, tell me that this human head louse (*Pediculus humanus capitis*) looks like a Ninja Turtle.
RIGHT My grandkids tell me that this springtail (Collembola) looks like a creature from *Star Wars*. Perhaps people who dream up movie characters get some of their inspiration from insects.

An immature treehopper (Membracidae) has produced a new cuticle and emerged through the opening that can be seen in the top of this old one. The discarded cuticle shown in this micrograph is a precise replica of the insect that shed it.

2 | exoskeleton

THE EXOSKELETON of insects and other arthropods is something like having a skeleton on the outside, because like bones, the exoskeleton provides support for the attachment of muscles. The outside of the exoskeleton, called the cuticle, also protects the internal organs and acts as a moisture barrier. The cuticle is composed of nonliving material and therefore does not grow. Underneath the cuticle are cells that can produce a new cuticle. Basic to the structure of insects and other arthropods is that in order to increase in size, the animal must shed its old cuticle and produce a new larger one. The process is called molting.

When an insect molts, the tissues beneath the cuticle produce a new, soft cuticle below the old one. Then the insect enlarges, usually by swallowing air. As the insect enlarges, the old, hard cuticle splits open and the insect slips out in its new, larger cuticle, leaving the old one behind. At first the new cuticle is soft and pliable and generally continues to increase in size as the insect takes in more air. It then hardens and can no longer enlarge. The number of molts that insects undergo varies from a few to over a dozen depending primarily on the species. The final molt produces the adult animal. An adult insect will never molt again and never grow any larger. This is true of all but the most primitive insects, and is why adult insects of many species are practically the same size, although females of some kinds of insects are larger than males.

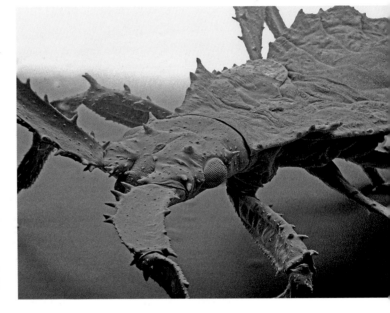

With its stiff plates and spines the exoskeleton of this insect (Hemiptera) from the Amazon rain forest is reminiscent of a suit of armor.

The exoskeleton of some insects resembles plate armor of the knights from the European Late Middle Ages. In insects the plates are called sclerites. Even the pointed processes, called spines in insects, may appear similar to the studs that were fabricated into some suits of armor. However, unlike the medieval knight in his cumbersome suit of armor, most insects are amazingly agile as they walk, run, jump, fly, and swim almost everywhere on earth.

The cuticle of the insect exoskeleton is composed primarily of chitins and proteins and has a wax coating that protects the insect from drying out. Chitins are polysaccharides, molecules composed of many sugars linked together. There are

various types of chitins with different physical properties depending on the kind of sugar molecules that the polysaccharides are made of and how the sugars are linked. The physical characteristics of an insect's cuticle also depend on various proteins in the cuticle and how the polysaccharides are attached to these proteins.

The thickness and properties of chitin are different in various parts of the cuticle. For example, the segments of an insect's legs or antennae may be made of hard chitin. However, soft, rubbery chitin or an elastic protein called resilin connects these segments. This enables the segments to articulate on one another. The thickness and the properties of the cuticle also vary considerably among different insects. Insects that depend on their exoskeleton for protection have thick, rigid cuticle, whereas insects that need to fly or run fast have relatively thin, light cuticle. Most beetles are an example of insects with a rigid cuticle that functions as protection. With some exceptions, beetles are slow-moving insects that either cannot fly or fly infrequently and for

Ants have hard cuticles. Their tough cuticle and powerful jaws enable ants to defend themselves against almost any predator their size. Even a spider of equal size is usually no match for an ant. In fact some kinds of spiders have evolved to resemble ants in order to discourage predators.

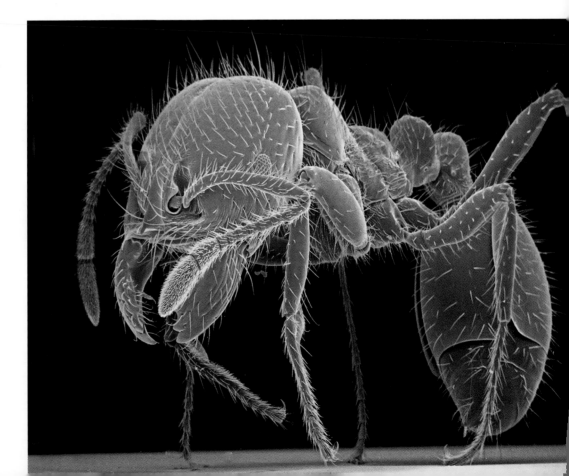

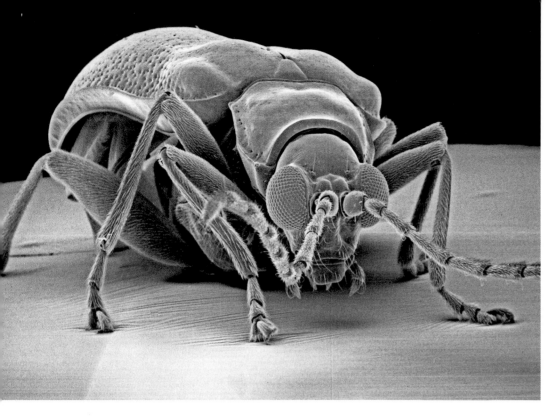

Like most beetles this one has a thick rigid cuticle, which protects the underlying structures. However, a thick cuticle is relatively heavy and cumbersome. As a result many kinds of beetles are slow moving and fly feebly or cannot fly at all.

This is a human head louse (*Pediculus humanus capitis*). Because lice spend their lives crawling around on hairs or feathers, they may be crushed when the "host" animal scratches or grooms. Their cuticle is thick, although rubbery rather than hard like the cuticle of beetles. However, the flexible rubbery cuticle is protective; lice are very difficult to crush.

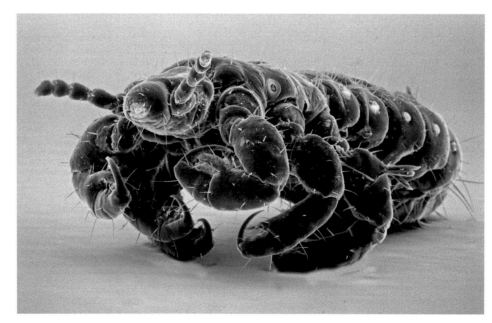

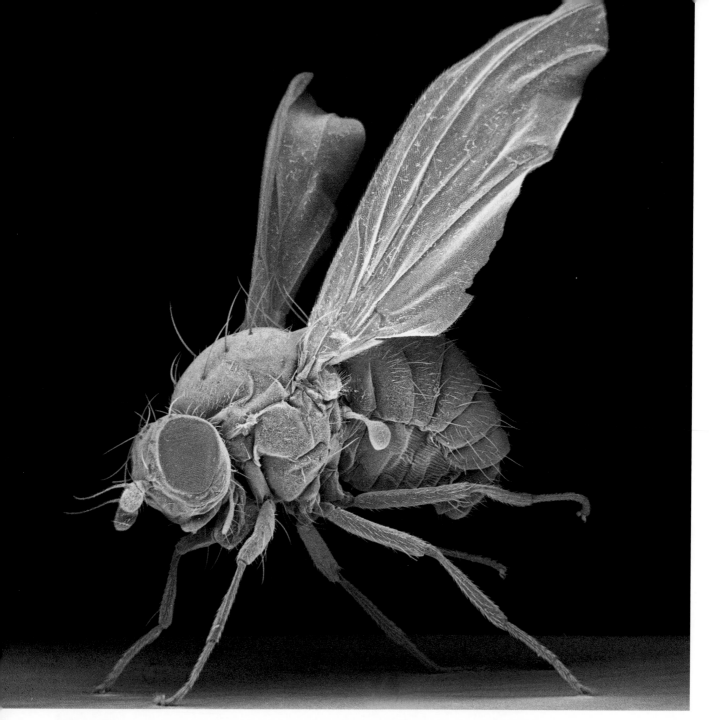

Flies, like this one, have thin, light cuticles that can be easily punctured by a spider or predatory insect. They depend on their relatively keen eyesight and their speed and agility in the air to escape danger.

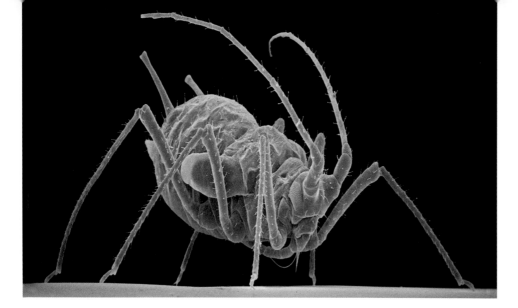

This small wingless aphid (Aphididae) has a very thin, soft cuticle. Because most of us spend our lives at ground level, we may not appreciate that a little insect high up in a plant or tree has a long way to fall. Insects with thin, soft exoskeletons do not fall to their death, even if they can't fly and yet drop from hundreds of feet. This is because of their small size. The surface area of very small objects is very large relative to their mass. A small insect is slowed so much by the resistance of the air that it reaches its maximum velocity in a short distance and lands at the same slow speed whether it falls from two feet or two hundred feet.

only short distances. They sacrifice speed and agility for a protective hard, thick cuticle.

The hard, rigid cuticle of many kinds of beetles contrasts with the light, delicate cuticle of various other groups of insects. Although a lightweight cuticle isn't as protective as a thick, hard one, it allows insects to run or fly rapidly. Dragonflies have lightweight cuticles. They are built for speed and maneuverability in the air. Dragonflies can fly fast, accelerate rapidly, turn on a dime, fly backward, and hover. They even eat and mate while in the air. In fact, dragonflies are so adapted for life on the wing that they cannot walk and are relatively easily crushed by predatory insects with harder cuticle, that is, if the predators can catch them.

Cockroaches have thin, lightweight cuticle. The bodies of these mostly nocturnal insects are flat so that they fit under logs and rocks (or kitchen cabinets), where they hide in the day. Cockroaches depend largely on their ability to detect danger and run rapidly over almost any surface in order to escape predators. Their relatively thin, lightweight cuticle contributes to their speed on the ground, just as a dragonfly's lightweight cuticle enables it to fly fast.

The insect cuticle has a thin wax coating that renders it impermeable to water. Imagine a tiny insect sitting on a leaf in the sun. If its cuticle were not able to protect the insect from evaporation, the animal would dry up and die in a short

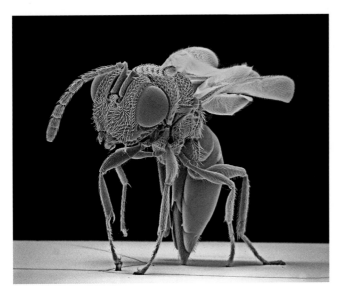 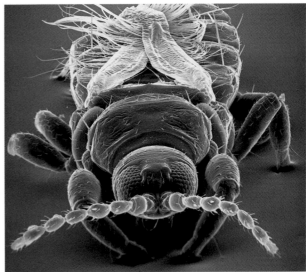

LEFT This microwasp (Trichogrammatidae) is smaller than a pinhead. Its cuticle is extremely thin and yet is resistant to evaporation as a result of its waxy coating.
RIGHT This is a thrips (Thysanoptera). (The word *thrips* is both singular and plural.) If you look closely at a flower petal, you may see tiny moving dark specks. These are thrips. They are sometimes exposed to direct sunlight, yet the wax coating on their cuticle protects thrips from evaporation.

time. The cuticle with its wax coating is also found lining the insect's digestive and respiratory tracts, since they too need to be protected from evaporation.

Segmented bodies characterize all arthropods. Although insects and other arthropods move by articulating segments on one another, the moving segments are difficult to appreciate with the naked eye, because insects move fast and are small animals. The reason that there are no large insects is controversial. A common theory holds that if an insect were as large as a lobster, it would be crushed by the force of gravity when it molted. Aquatic arthropods can be larger because they are buoyant and thus don't have to contend with

gravity when they molt. Observing a lobster in an aquarium at the supermarket is a good way to appreciate the segmented nature of arthropods. Segments can be seen to articulate on one another when the lobster moves its legs and tail.

There is reasonable agreement among experts that the exoskeleton of the ancestors of modern insects was composed of segments of similar size and shape, each with a pair of legs. As insects evolved, the segments changed such that they were no longer all the same size and shape. Legs disappeared from some segments or evolved into other structures. The segmented body is still characteristic of insects, even though the individual

Many insect larvae, including maggots, caterpillars, and beetle grubs like this one, telescope their segments on one another for locomotion. Although this means of travel is slow, many kinds of insects lay their eggs on a food source so that their larvae have no need to go very far.

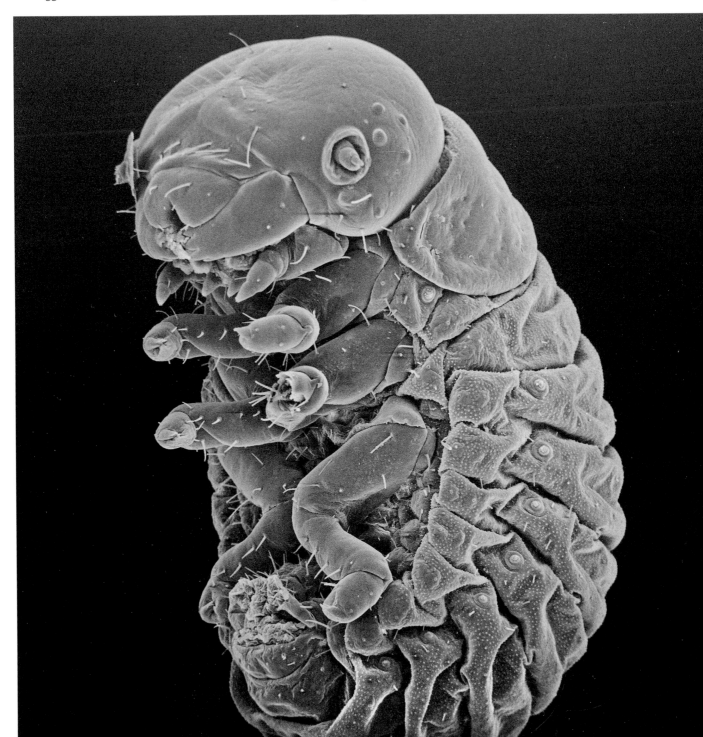

The individual segments of a beetle's abdomen are not apparent when beetles are viewed from above, because its abdomen is covered with the animal's forewings. However, the abdominal segments can be appreciated when the beetle is viewed from below, as in this micrograph.

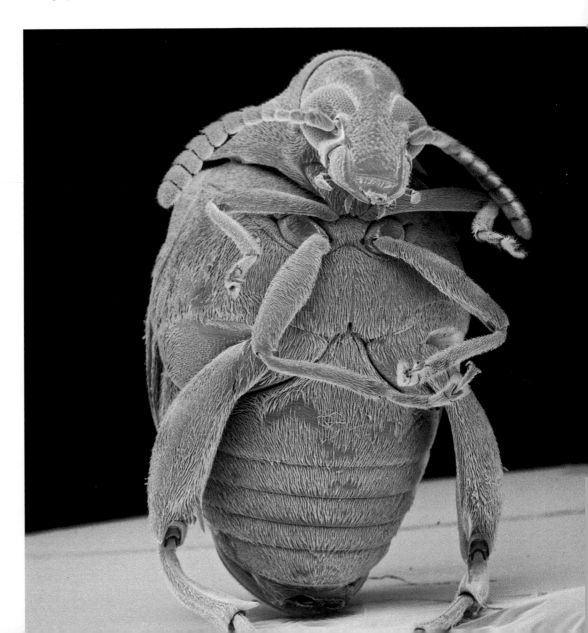

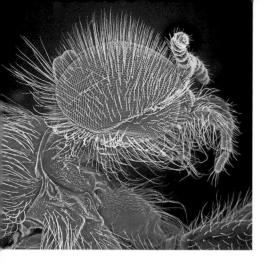

segments may not be readily apparent, either because most insects are small or because large sclerites or wings cover them.

Most insects are covered with hair. However, because insects are so small, their hairs are often not obvious to the naked eye. Most insect hairs are sensory structures called setae. Setae come in various shapes. When they are large and tapered, they are referred to as bristles, and when they are flattened, setae are called scales. Setae have in common that they are connected to sensory nerves.

Hairs are the most common setae. Those on the feet of an insect provide the sensation of touch, enabling an insect to detect vibrations or to keep its balance and to know where to place its feet. Have you ever tried to sneak up on a cockroach? The slightest movement of the floor is sufficient to send the cockroach scurrying for cover. Hairs on the antennae of insects typically enable the insect to detect volatile or vaporized molecules. Other hairs may alert an insect to the

Because they are so small, the hairs on some insects, such as this wasp, may not be obvious to the naked eye, but the wasp is nonetheless covered with sensory hairs (setae). We recognize our surroundings primarily through our eyesight and hearing and to lesser extent through smell and touch. For many insects setae as well as other receptors in the exoskeleton are their most important means of perceiving their surroundings.

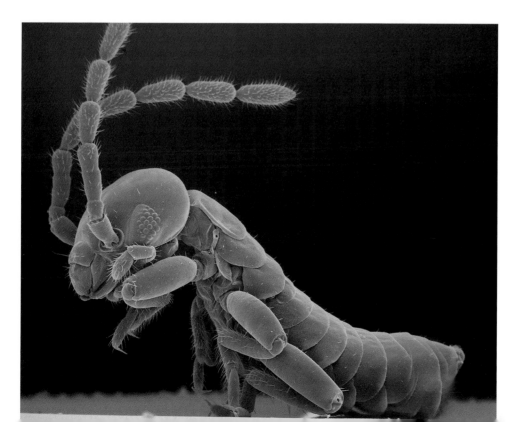

Because this little immature earwig (Dermaptera) has no wings covering its abdomen, the segmented nature of its abdomen is readily apparent.

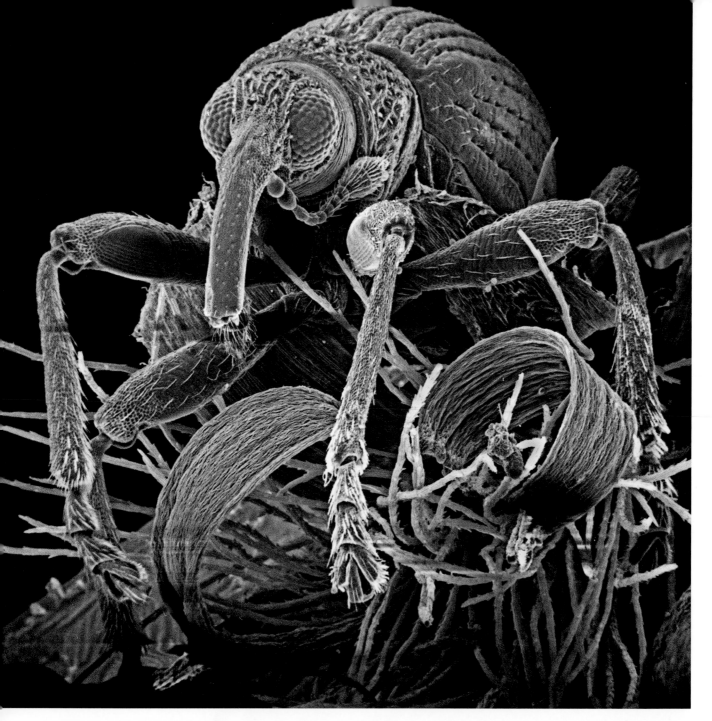

Insects, such as this weevil, have to walk over some very rough terrain. Numerous setae on their feet and legs enable insects to keep their equilibrium. Hairs on their legs and feet also sense vibration.

presence of prey or predators, or may determine wind velocity and direction.

Although some insects, such as grasshoppers and crickets, possess specialized organs in their head, legs, wings, or abdomen for hearing, hairs are the "ears" of most insects. It may seem strange that hairs can function as ears. However, sound consists of vibrations that travel through the air (sound cannot travel through a vacuum). We hear by virtue of small bones in our middle ear that are caused to pulsate by the vibrations of our eardrums. Similarly, some insects hear by vibration of their hairs. Hearing is very important to many insects because many kinds of insects use sound to communicate. Also many insects detect bats by the high-frequency sounds that bats use to navigate.

In addition to being sensory organs, hairs can serve other functions. Hairs on the body and particularly the legs of bees play a key role in gathering pollen to feed their young. The pollen

This micrograph shows insect setae. Unlike human hairs, which are the same diameter throughout their length, setae are tapered and are different lengths depending on their particular sensory function.

from flowers readily attaches to hairs. Interestingly bees, wasps, flies, and certain other pollinators, including butterflies, evolved about 150 million years ago, at the same time as the emergence of flowering plants. The simultaneous appearance of pollinators and flowering plants is presumably not a coincidence, as the insects and plants have a symbiotic relationship wherein the insect feeds on the flower's nectar and pollen and the flowering plant benefits from the pollinators

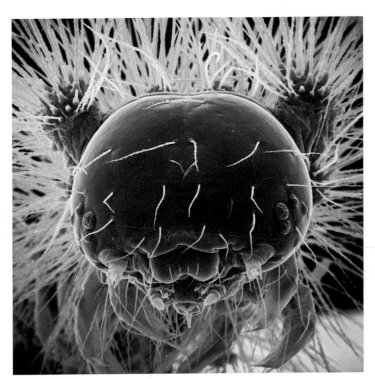

for its reproduction and for genetic diversity. (Although most flowering plants have both pollen and ova, they cross-fertilize in order to retain genetic diversity.)

In addition to hairs, some insects have larger setae called bristles. Some bristles serve sensory functions, whereas others, such as the bristles on the feet of some insects, give the insect traction, functioning something like cleats on athletic shoes. There are also bristles on other parts of some insects' bodies that provide protection.

Bristles are essential to fleas (Siphonaptera). These insects have strong back legs for hopping, and bristles give them traction when they hop. However, most bristles enable fleas to cling to the bird or mammal they

Numerous bristles can be seen behind the head of this fuzzy caterpillar. Caterpillars move too slowly to escape most predators, but they have a number of ways to protect themselves, including bristles. Because songbirds find bristles unpleasant to swallow, most songbirds avoid caterpillars that have bristles. Bristles also make it difficult for parasitoid wasps to get close enough to lay their eggs on (or in) caterpillars. (Parasitoids are parasites that kill their hosts.) The protective bristles of some caterpillars are hollow and have a poison gland at their base. Depending on the species, the caterpillar may either synthesize poison or obtain it from plants it feeds on. Some kinds of caterpillars secrete poison through the bristles such that they are constantly covered with the substance. Contact with these caterpillars can be irritating to both predators and humans.

This is a bee. Not all its hairs serve sensory functions. Some bees have rows of hairs on their legs called combs. Combs on the hind legs of bees are specialized for gathering pollen. Combs on other legs detach the pollen when the bee returns to her hive. The hairs on bumblebees help the animal to retain heat. Insects generate a lot of heat when they fly, and large insects retain heat better than small insects because they have less surface area relative to their mass. Hairs allow bumblebees to visit flowers on days that are too cool for most other flying insects that compete with them for nectar and pollen.

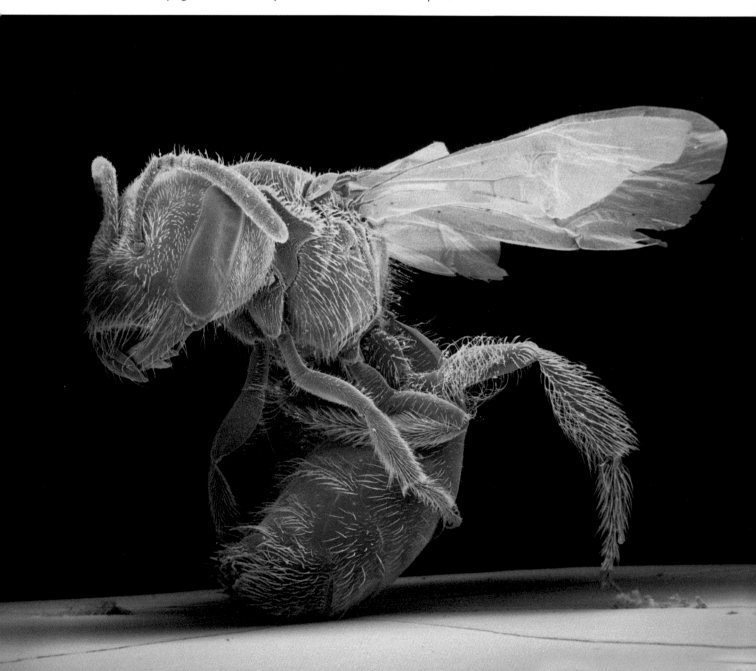

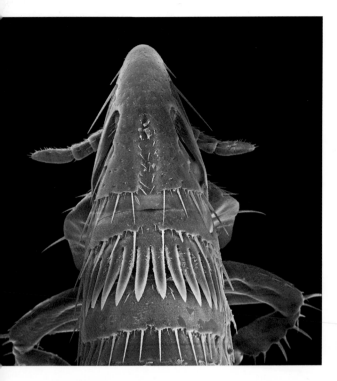

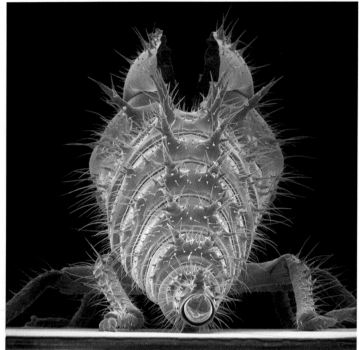

This flea is viewed from above. Fleas are relatively flat from side to side. Their flattened body enables fleas to crawl between a host's hairs or feathers. Bristles that are arranged like a comb enable fleas to hold on tenaciously to their host.

The spines on the back of the abdomen of this insect (Hemiptera) are for protection. This micrograph actually shows the molted cuticle of the insect. However, because the old cuticle is a replica of the insect that emerged, the spines look just as they would on the insect before it molted.

live on so as not to be dislodged when the animal scratches or grooms. Some of the setae of fleas are collectively called combs, because they are arranged in a row like the teeth on a comb.

The rat flea has altered human history, because it harbors the bacterium that causes the bubonic plague. This bacterium has evolved a unique method to increase its dispersal. Fleas feed on blood. When bacteria are ingested along with the blood from an infected animal, they multiply and lodge in the flea's digestive tract, where they block the intake of more blood. Because the flea is not obtaining nourishment, it continually bites its host and in doing so transfers more bacteria with each bite, helping to ensure that any rat or person that it bites will become infected. Plague bacteria that were present in the feces of rats also infected people. In all, the bubonic plague has killed an estimated 200 million people worldwide.

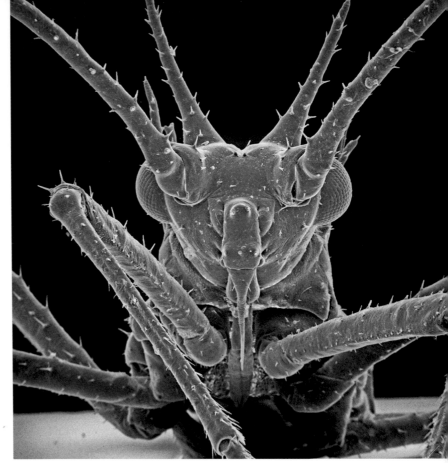

The two large spines between the antennae of this insect (Hemiptera) are somewhat reminiscent of the horns of an antelope.

Many insects have large pointed spines for protection. The spines act something like the spines of a hedgehog. Other spines are used offensively. The males of some insects are territorial. They will use their spines to fight off other males of their species that wander into their territory. Like many mammals they become very aggressive when battling for mates. For some of these insects spines function as jousting weapons, like the antlers of male deer. As is the case with most mammals, the loser is usually not killed but sulks away in defeat while the winner gets mating rights. Males of a group of beetles apply named rhinoceros beetles have giant spines, which are employed to jostle with other males for territory and mating rights.

Scales, like other setae, often serve sensory functions. Unlike hairs and bristles,

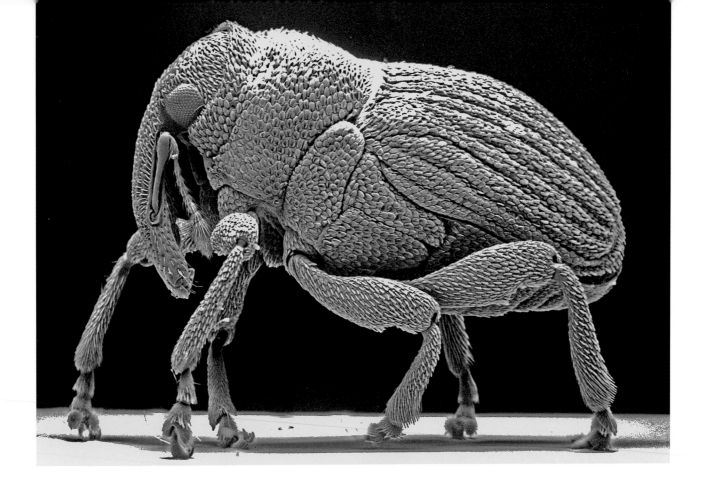

Like most other beetles, snout beetles (Scolytinae) have thick, hard cuticles for protection. Some kinds of snout beetles are covered with hairs, whereas other species, like the weevil shown in this micrograph, have scales for protection. The setae near the weevil's feet appear to be a blend of scales and hairs.

scales are flattened and have blunt ends. Some species of snout beetles, also referred to as weevils, are covered with scales. Snout beetles usually feed on seeds, and most species have a limited number of host plants; some have only one. Unfortunately wheat and cotton are the host plant for some species of snout beetles. In the 1920s boll weevil infestations throughout the entire cotton-growing region in the southern United States devastated the

industry, affecting millions of livelihoods. A single boll weevil can lay as many as two hundred eggs and have as many as eight generations in one crop season. If all the offspring lived, this would result in over 100 million beetles in one year from a single pair of beetles. It should be said that the boll weevil was a factor in the use of crop rotation in the southern United States. Thus, like many things that at first seem distortions, this little weevil

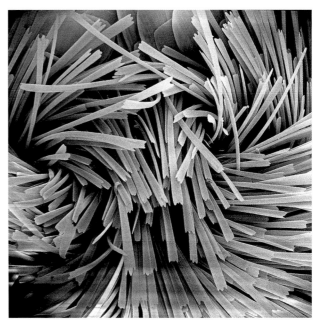

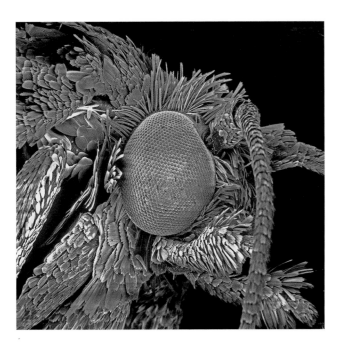

The head of this moth has an abundance of intricately arranged scales around its eye.

This micrograph of moth scales is black and white because colors are a phenomenon of light and thus not seen in images produced by electron microscopes. The colorful patterns on the wings of butterflies and some moths serve to attract the opposite sex of their species, or to warn predators that they are poisonous. These beautiful and, in some species, iridescent color patterns are imparted by scales. We think of colors as being brought about by pigments: leaves are green because of chlorophyll, carrots orange because of carotene. However, pigments are not responsible for all colors; they do not cause, for example, the colors of a rainbow or those of an oil slick. The colorful patterns of butterfly wings are imparted by multilayered, thin, complex-shaped scales. Typically scales have ridges, furrows, and other complex surface features that reflect particular colors (wavelengths of light).

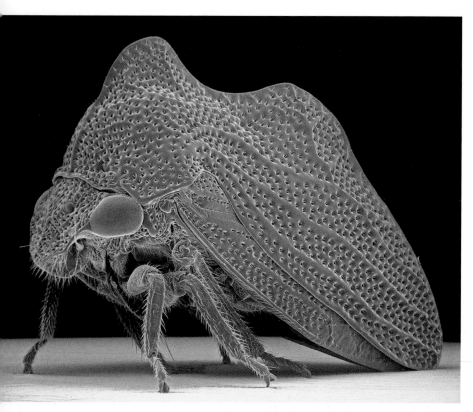

may have been more beneficial than harmful in the long run.

The most elaborate scales may be those that cover the wings of butterflies and moths. Different sizes and shapes of scales fit together in precise and intricate patterns over the entire cuticle of some moths. Scales play an important role in protecting butterflies and moths because they frequently fly into spider webs. Moths are especially vulnerable because they fly at night, when it may be too dark for them to see, and most spiders are nocturnal. If a moth becomes snagged in a spider web, its scales are designed to stick to the web and detach so as to set the moth free.

Most treehoppers (Membracidae) resemble thorns. Sitting motionless on a twig, a treehopper may not be noticed by a predator. Treehoppers of the same species may line up in a row on the stem of a plant facing the same way so that they resemble a row of thorns.

It is likely that scales also contribute to the aerodynamic properties of these relatively large insects. Scale-covered wings are relatively smooth. Hairs would protrude and likely cause turbulence that would slow the butterfly or moth down and result in less efficient flight, such that a butterfly or moth would have to consume more food in order to fly a given distance. A number of species of moths and butterflies migrate long distances. Presumably aerodynamic wings help to facilitate these long journeys.

In the 1920s luxury-coach companies made various car bodies that would fit over frames made by automobile companies. Very different-looking bodies could be manufactured to fit the same frame. In an analogous way there are insects that are similar inside but have very different and sometimes elaborate or strangely shaped exoskeletons. To camouflage themselves, many insects have evolved shapes that look like something other than an insect. Indeed, there are insects that resemble sticks, leaves, thorns, tree bark, and even bird droppings.

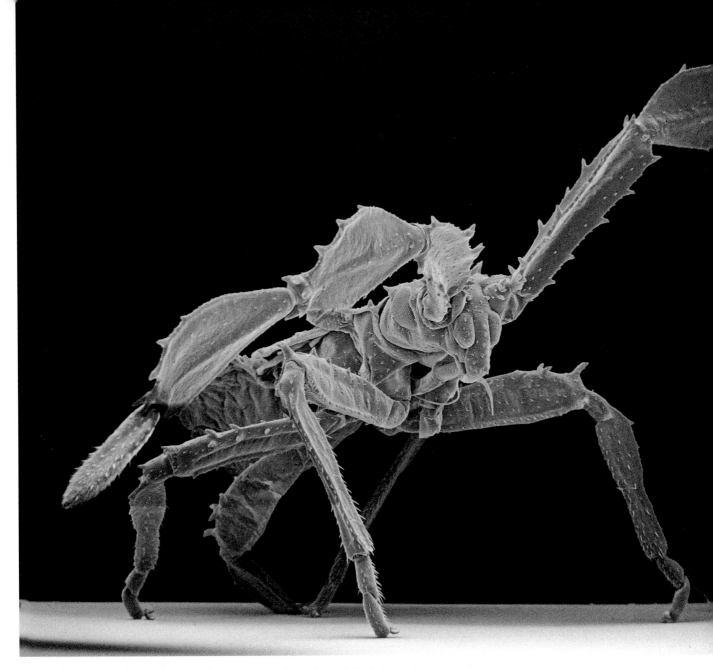

Insects thrive in rain forests because they are warm, humid, and full of plants. However, along with insects that feed on plants, there are many insects, spiders, and other animals that eat insects. To avoid detection, the exoskeletons of many rain forest insects are camouflaged to look like parts of plants. This true bug resembles the leaves or stems of a thorny plant.

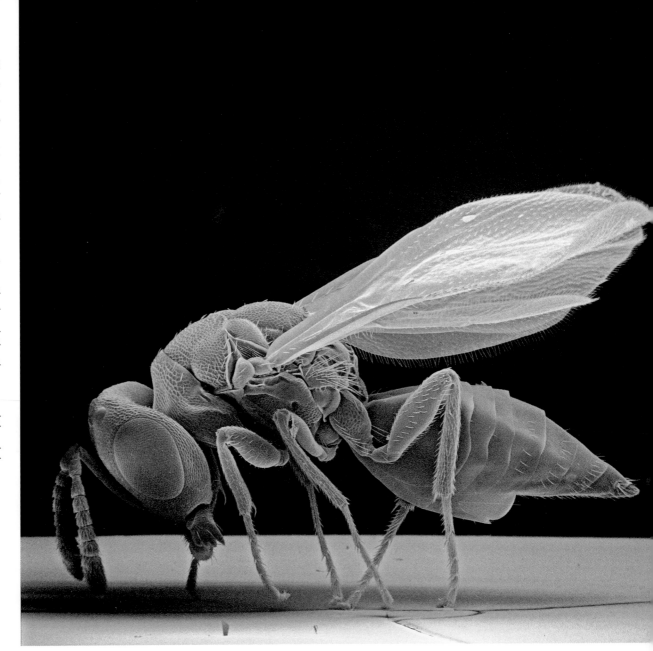

The body of most insects has three regions: the head, the thorax, and the abdomen. Although the three separate regions are not always apparent, they can be readily distinguished in this micrograph of a wasp, because the connections between the head and thorax and between the thorax and the abdomen are narrow.

3 | parts

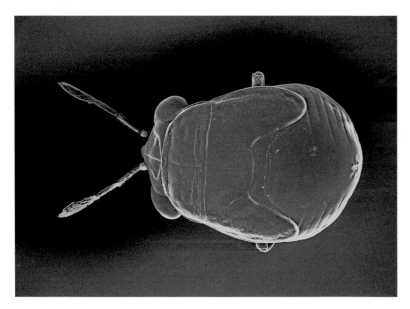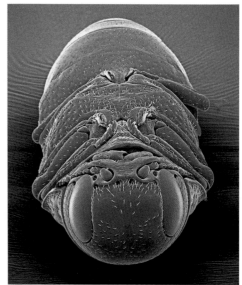

LEFT In insects that undergo incomplete metamorphosis, immature animals look like adults but do not have wings. However, many such insects, like this negro bug nymph (Thyreocoridae), have wing pads that develop into wings. Negro bugs use sounds to attract mates. We are familiar with the songs crickets and katydids use to call their mates. Many kinds of little insects also call their mates, but the sounds are not audible to our ears.

RIGHT In insects that undergo complete metamorphosis, the larva becomes a quiescent pupa, which is transformed into the adult. Pupation is a process somewhat similar to the development of an embryo. Some cells proliferate; others die. Organs and limbs are remodeled, reorganized, or built anew. This micrograph shows a beetle pupa. It is somewhat reminiscent of a human mummy.

THE BODY of adult insects has three regions: the head, which contains the eyes, antennae, and mouthparts; the thorax, which contains the legs and wings; and the abdomen, which contains the respiratory system, most of the digestive tract, and reproductive organs.

There is considerable variation in the anatomy of immature insects. In primitive insects that most resemble the ancestral types, the young look like miniature adults. In somewhat more advanced insects the young resemble adults, but their body parts are proportioned somewhat differently, and

TOP This is an ant pupa. In complete metamorphosis pupae are usually helpless. The best they can do is twitch. Although this is a dangerous time for most insect species, it is not such a problem for ant pupae, as they have many fierce big sisters to protect them.

BOTTOM A number of insects that live on land have aquatic larvae termed naiads. When I caught this beetle naiad, it was creeping around on an underwater plant, probably looking for little insects to eat. Most naiads are carnivores.

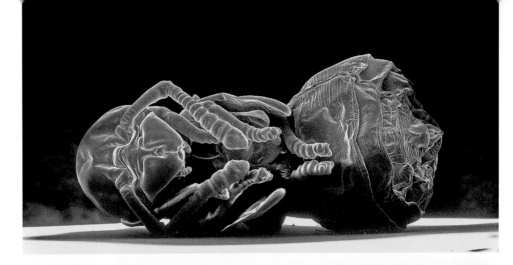

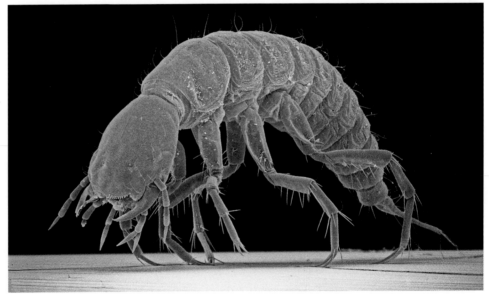

they generally lack wings and genitalia. These young insects are usually called nymphs, and their development is called incomplete or simple metamorphosis. Then there are some insects whose young appear something like adults but have major differences. For example, immature dragonflies and mayflies are aquatic and have some of the features of adults but are so dissimilar that they might be mistaken for a different kind of insect.

In the most advanced insects the young, usually called larvae, look nothing like adults. For example, maggots don't look like flies, and caterpillars don't look

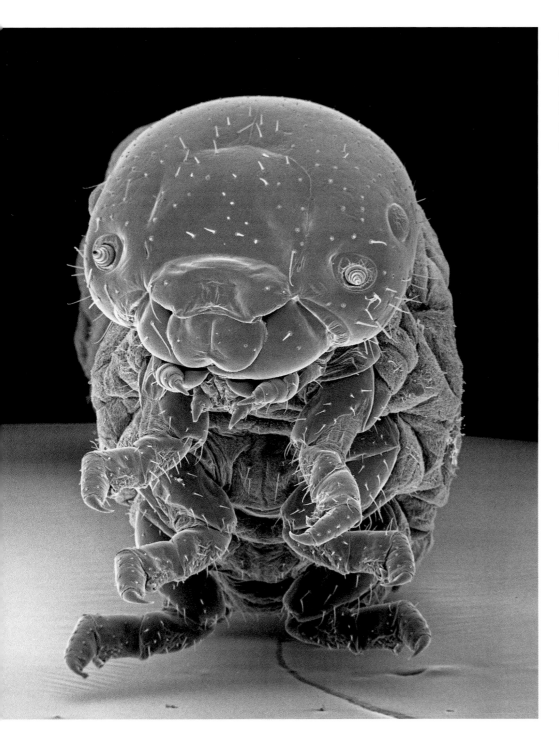

Although the larvae of some insects that undergo complete metamorphosis are legless, others, like this beetle larva, have small legs.

like butterflies. In these insects larvae undergo radical metamorphosis to become adults. The maggot, grub (fat larva of many insects), or caterpillar forms a quiescent pupal stage in which the larva is transformed into an adult. This type of maturation is often called complete metamorphosis. There is a good reason that the larvae and adults are so different. The larvae are specialized for feeding and rapid growth. On the other hand adults are designed to reproduce and may need to feed only a little to stay alive long enough for mating, while in other kinds of insects adults do not feed at all.

This is a microwasp. Some species of microwasps are so small they cannot be seen with the naked eye. The larvae of many of these wasps develop inside other insects. Because some adult female microwasps may lay their eggs inside larger, more formidable insects, they need to be very agile so as not to be killed by the potential host.

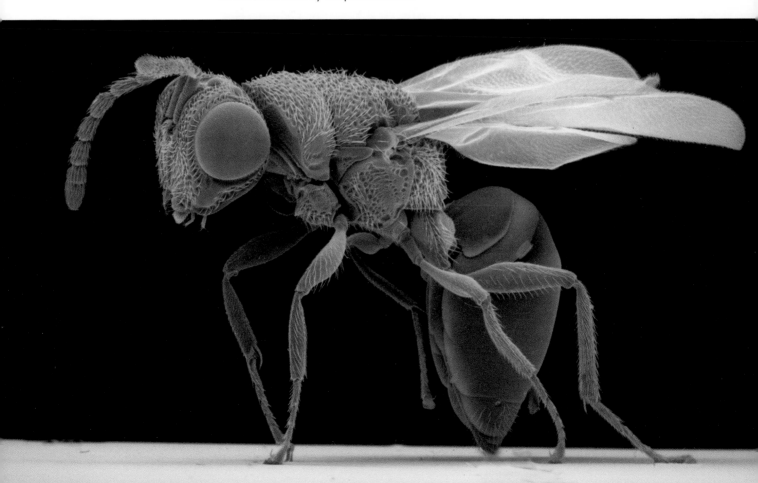

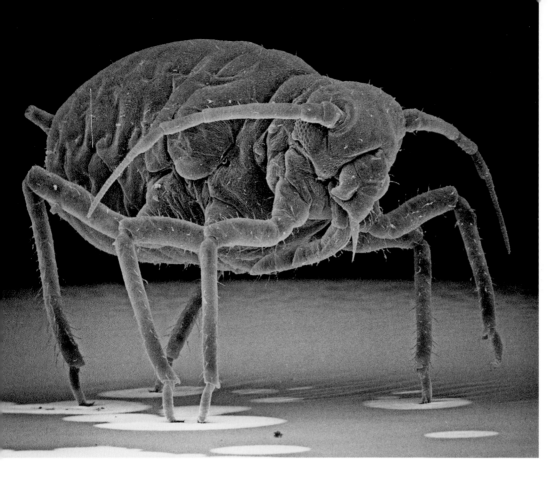

This is an aphid. Because they are small, aphids can go through several generations a year. This enables them to maintain their population faster than they are eaten, even though they have many predators.

The majority of insects are very small. There are advantages of being a small insect, or there would not be so many. Tiny insects are able to reproduce faster than large insects; many species may go through several generations in a year, which enables them to maintain their population even when they are subject to intense predation. Minute insects are also able to live in little crevices such as cracks in the bark of a tree where larger insects could not fit. And tiny insects may be too small for many predators to notice or want to attack. In fact, spiders usually do not strike insects that are much smaller than they are, either because they do not detect them or because they judge them too little to be worth using up poison for. In addition, tiny insects are carried by the wind, which enables them to find new territories.

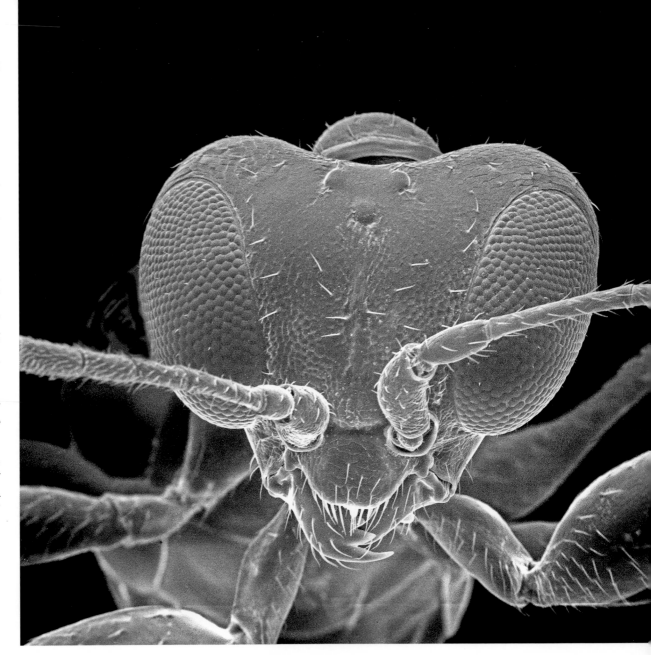

The eyes, antennae, and mouthparts are obvious in this micrograph of a wasp's head. In a scanning electron microscope the subject can be rotated or tipped so that it can be viewed from different angles. The head of the same animal viewed from the side can be seen on page 29.

4 | head

IT IS IMPORTANT for us, and many other animals, to be able to turn our head in order to look in different directions to climb, swim, or eat. Although the visual acuity of most insects is not very good, they usually can see in all directions, so they do not have to turn their head to see what is above, below, or behind them. However, for many functions, including feeding, mating, and cleaning their legs or antennae, insects need to turn their head. Unfortunately, the anatomy that enables an insect to turn its head renders the insect vulnerable to getting its head bitten off. Thus, depending on the insect's lifestyle, some insects can turn their head in most every direction, whereas in other insects the ability to turn their head is limited.

RIGHT In most beetles, like this one, the head fits tightly into the thorax and thus has limited motion. Most beetles depend on strength rather than agility, so it is important to have their head joined to the thorax in such a way that it cannot easily be bitten off.

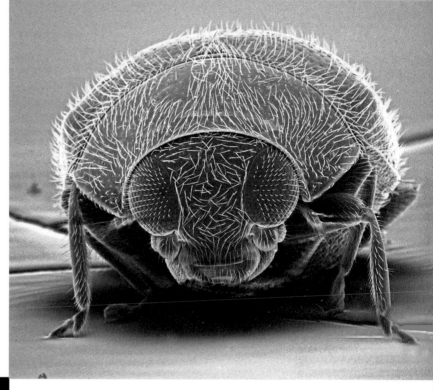

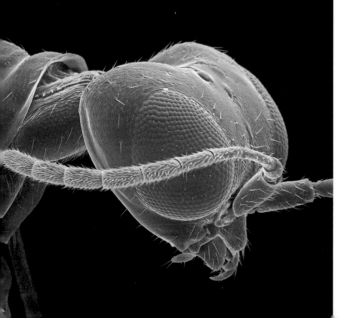

LEFT Many insects frequently clean their antennae and legs. To accomplish this, the insect turns its head while passing an antenna or limb through its mouthparts. The thin stalk connecting the head and thorax allows wasps to turn their heads.

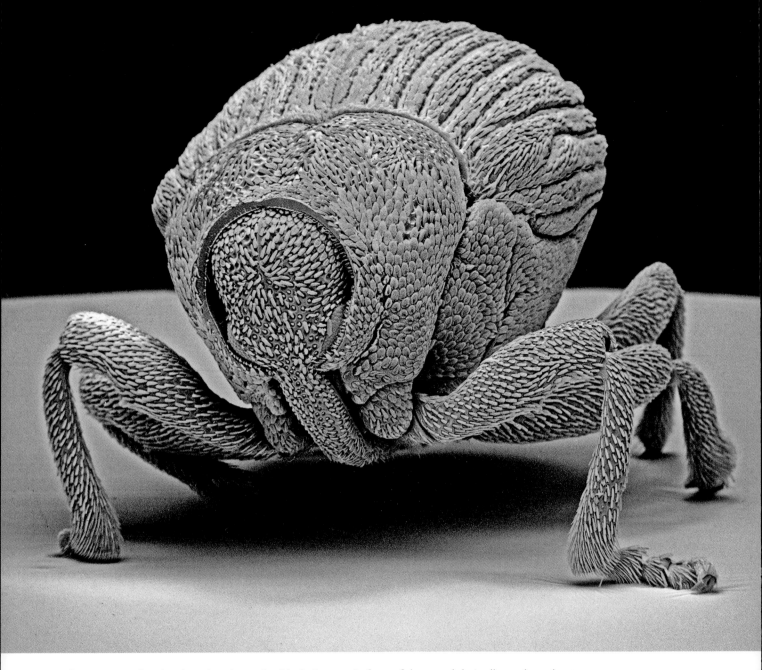

This is a snout beetle. These beetles walk with their snout in front of them and their elbow-shaped antennae waving to detect their surroundings. However, when they sense danger, snout beetles tuck their head, snout, and antennae underneath their thorax in the position that can be seen in this micrograph.

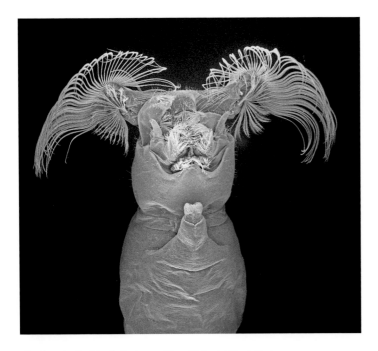

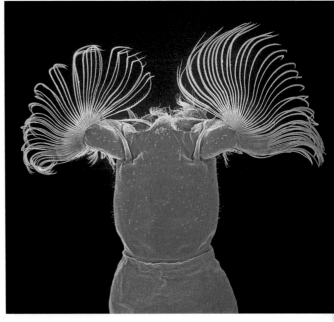

The head of a black fly larva (Simuliidae). Black fly larvae are aquatic. They attach to rocks in fast-moving streams and use their fan-like filters to trap the bacteria and algae they feed on. Note that there are hairs around the larva's mouth. Presumably these filter out large particles so that only the microscopic bacteria and algae are consumed.

The black fly larva's filters are shaped like a scoop. As the filters constantly move back and forth, they direct bacteria and algae toward the larva's mouth.

Although the principal external structures of the insect head are its eyes, antennae, and mouthparts, the head of the aquatic black fly larva is unusual because two fan-like structures protrude from it. These structures are filters, which rapidly move back and forth, forcing trapped food particles toward the black fly larva's mouth. A number of other animals including clams, shrimp, flamingos, and some kinds of whales and sharks are filter feeders. All these animals have some type of filter and a way to force water through the filter. Clams and oysters move water in and out of siphons that have cells with microscopic organelles, called cilia, that beat. Shrimp and their relatives have fan-like filters similar to those of the black fly larva, which are also constantly moving back and forth to trap food.

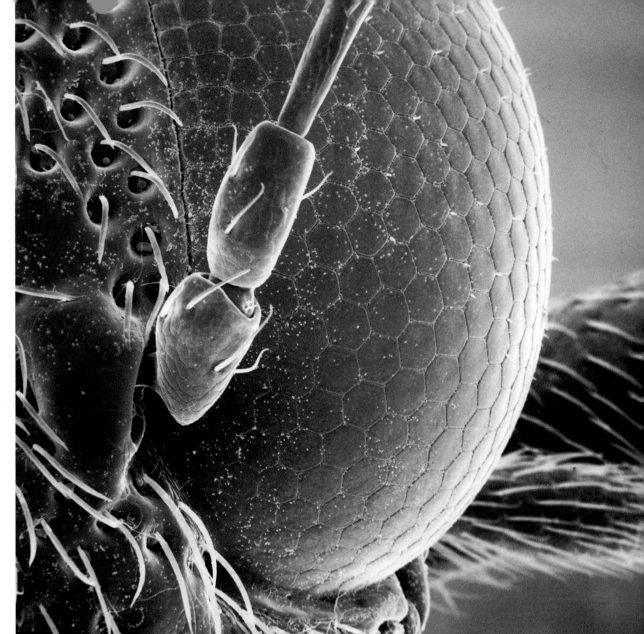

Insect vision can be pretty precise. This is the eye of a wasp. Wasps that live in colonies need especially good eyesight to detect the visual clues they use to find their way back to the nest.

5 | eyes

INSECT EYES are referred to as compound eyes because they are composed of a few dozen to thousands of individual eye units called ommatidia. The compound eyes of many insects, particularly those that fly rapidly such as dragonflies, wasps, bees, and many kinds of flies, take up most of the surface of the insect's head, and the majority of the brain of these insects is devoted to vision. These insects use their eyes to find mates, food, friends, and foes and to navigate forests and fields.

Because the eyes of insects are dome-shaped, each ommatidium faces in a slightly different direction from the adjacent ones. The total image an insect sees is thus composed of many individual images. It is convenient to think

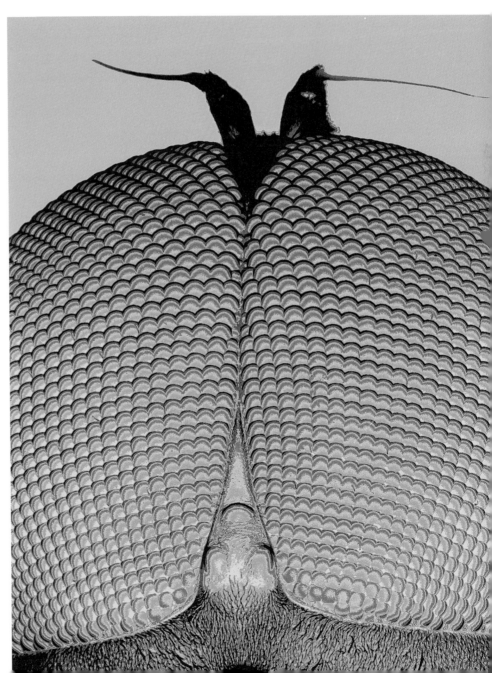

On the front of a fly's head are dome-shaped eyes. Many kinds of insects use their senses of smell and touch to perceive their environment. However, this doesn't work for insects that fly rapidly, because they need to see what is in front of them so they can maneuver to avoid objects or land on them. Most fast flies, such as the house flies, have large compound eyes composed of hundreds to thousands of ommatidia. Most of the brain of these insects is devoted to interpreting signals that come from their eyes.

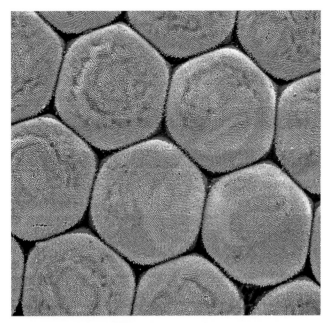 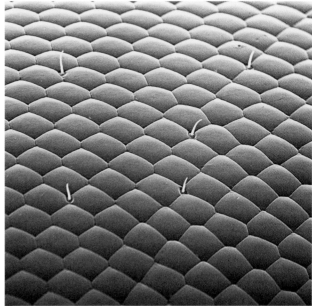

The precise arrangement of ommatidia is apparent in this micrograph of the surface of a compound eye. In many insects ommatidia are hexagonally shaped and are arrayed in a hexagonal pattern such that each ommatidium is adjacent to six others. Individual ommatidia capture the intensity and color of light as a spot or pixel. These pixels make up the image the insect perceives.

Although ommatidia are frequently arranged in hexagonal patterns, they may have different arrangements as the curvature of the eye changes. The ommatidia of this eye have slightly different arrangements in different areas.

of the image of each ommatidium as a spot or pixel of a certain color and light intensity, with no further detail. The total number of pixels is equal to the number of ommatidia in the compound eye. Thus, insects that have eyes composed of many ommatidia have more acute vision then insects with eyes composed of only a few ommatidia. Although the human eye is structurally very different from the insect eye, the images we observe are also mosaics of pixel-like dots perceived by individual photoreceptors in our retinas (though the human eye has over a million photoreceptors, whereas insects have at most a few thousand ommatidia). Like ommatidia, each photoreceptor in the human eye sees a slightly different image than the adjacent photoreceptors. We do not perceive images as having

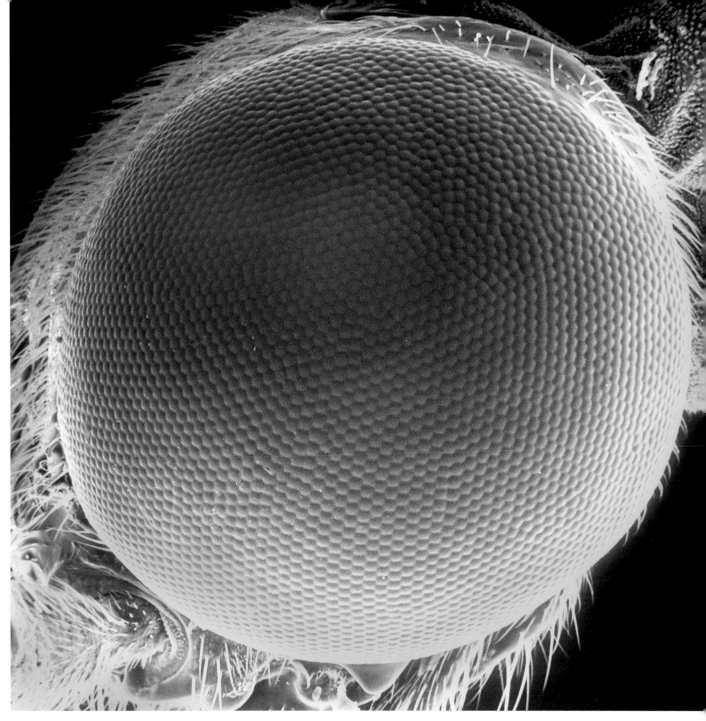

This eye has a few thousand ommatidia. If you were to color in certain ommatidia, you might be able to make a reasonably good likeness of, let's say, an approaching spider.

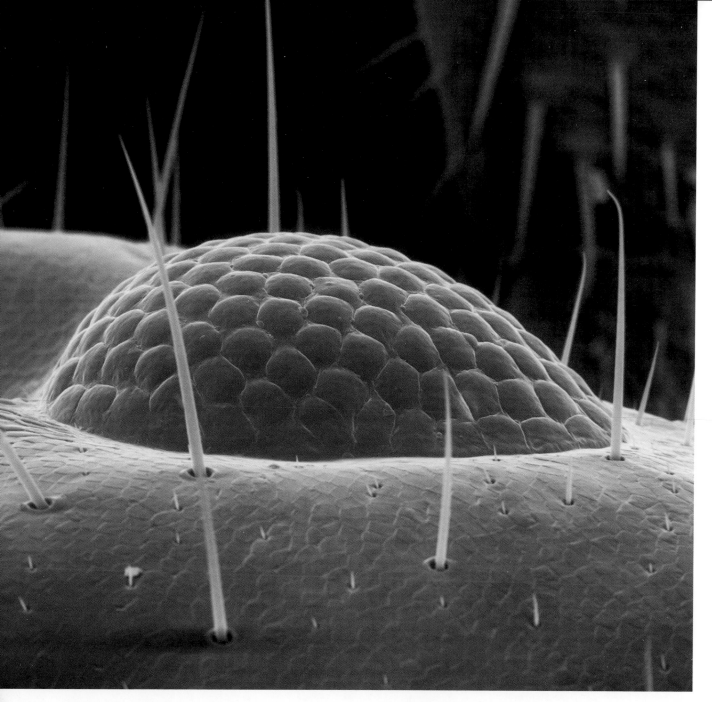

Insect eyes are dome-shaped such that each ommatidium faces in a slightly different direction. Unlike our eyes or those of a fish or even some invertebrates such as octopi, insect eyes cannot changes focus to obtain a clear image of objects at different distances.

individual spots or pixels, just as we generally do not perceive the images on our computer screens as being made of pixels. Nevertheless, the images we observe are composed of tiny individual dots, just like the images of a computer or the eye of an insect.

Our eyes and the eyes of other vertebrates change focus in order to see clearly objects that are at different distances from us. The compound eyes of insects cannot change focus. Rather, the eyes of most insects usually are permanently focused on objects that are very near. Thus, the visual world of most insects is their immediate environment.

Since most insects can't see far and thus don't recognize a predator until it is almost on top of them, they may have only a split second to escape being killed and eaten. However, a split second is a lot of time for insects, as their reaction time is many times faster than ours. Reaction time depends on the speed of nerve impulses and the distance they travel. Consider the reaction time of people; for example, the time a driver of a car takes to step

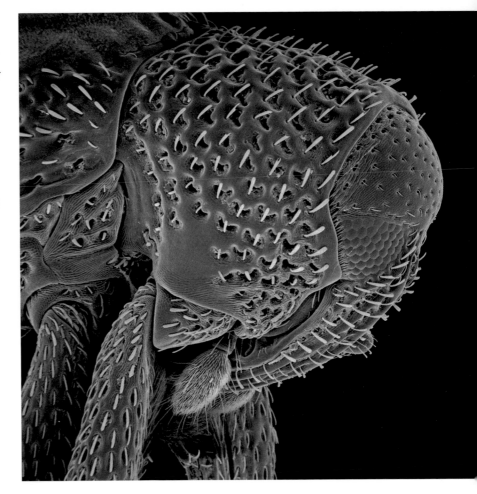

Like many kinds of snout beetles, this one is minute. Although its tiny eyes have only a couple of dozen ommatidia and can probably form only rudimentary images, the beetle can detect movement. Because insects are so skillful at detecting movement, it is difficult for predators to sneak up on them.

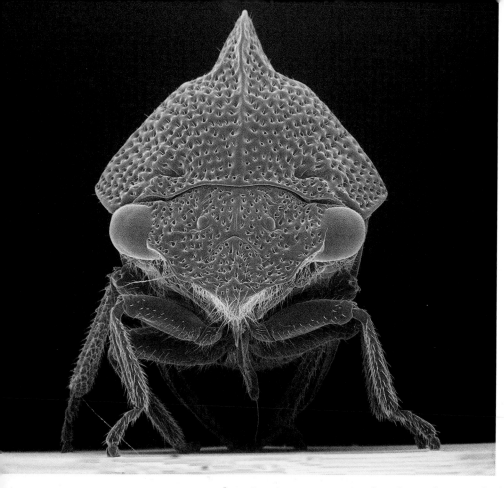

This treehopper is set to jump. With its eyes bulging out on both side of its head for panoramic three-dimensional vision, and a reaction time measured in milliseconds, the treehopper can detect danger coming from any direction and react almost instantly by catapulting itself into the air.

on the brake to avoid an accident. The driver's reaction time depends on the time it takes a nerve impulse to travel from his or her eyes to his brain and from the brain to his foot, and the time it takes for muscles to move his foot to the brake pedal. Nerve impulses for the driver's reaction time travel at about the speed of a jet airplane. As insects are small, their nerve impulses travel only a very short distance. Thus, an insect's reaction time is a many times faster than ours.

Although insect eyes are limited in some ways, in other ways they are superior to ours. In addition to the "visible" light our eyes detect, insect eyes can see ultraviolet (UV) light. Although invisible to our eyes, because UV light does not pass through the lens of the human eye, many leaves and flowers reflect ultraviolet light. The ability to detect different wavelengths of ultraviolet light aids insects in identifying flowers and plants. This is important because many adult insect species or their young feed on only one or a few kinds of plants. The characteristic pattern and wavelength of ultraviolet light reflected by flowers and other parts of plants helps these insects to determine which plants to feed on and/or to lay their eggs on.

The eyes of this jumping plant louse (Psyllidae) are very far apart. Some insects with eyes situated far apart can judge the distance to an object by shifting their body slightly from side to side while looking at the object.

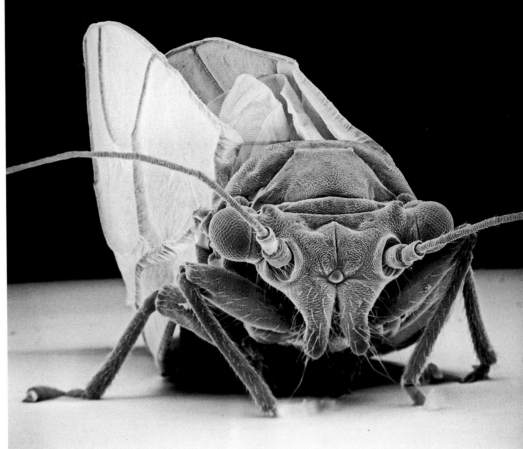

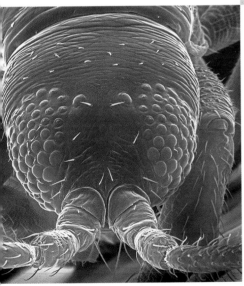

This is a micrograph of the head of a thrips. Its eyes are composed of very few ommatidia that are round and not arranged in hexagonal patterns. Although the eyes of thrips can't form clear images, they can discern colors.

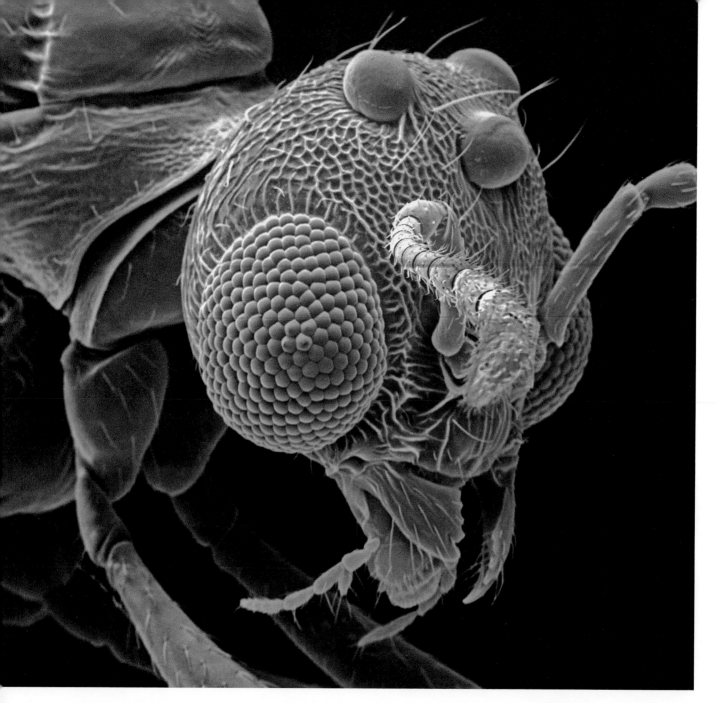

In addition to compound eyes, flying insects, like this wasp, have simple eyes called ocelli. They are the three hemispheric bulges on top of the wasp's head. As insects can be easily tossed around in the wind, they need to be constantly aware of their orientation with respect to the ground. Ocelli help flying insects to orientate themselves.

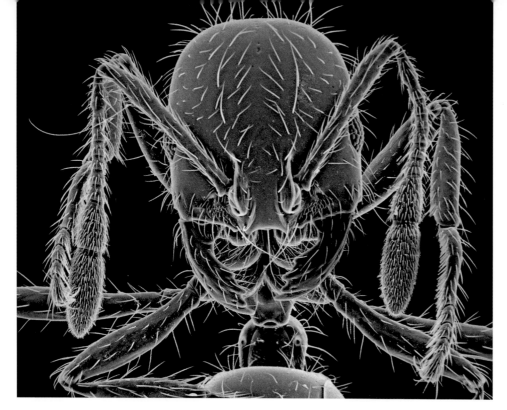

This worker ant has very small eyes. Ants have either small eyes or, in some species, no eyes at all. Sight is of no use in underground tunnels. Aboveground even blind ants get along fine by using their senses of smell and touch, and their ability to detect vibrations.

Insect eyes can also detect the plane of polarized light. The earth's atmosphere allows light waves that are parallel to the earth's surface to pass more readily than those that are not. Polarized glasses partially block these light rays. Thus, if on a sunny day you tilt your head when you are wearing polarized sunglasses, the light becomes brighter. The compound eye of insects can detect the plane of polarized light as polarized sunglasses do. Flying insects employ this aspect of their vision to determine how much their body is tilted relative to the surface of the earth.

Although the ommatidia in the eyes of insects with good vision are very regularly arranged, the ommatidia of insects with relatively poor vision are arranged in less regular patterns. These insects are guided by their senses of touch, smell, and taste, and their ability to sense vibrations. Their eyes may be used only to discern day from night. There are also insects with no eyes at all, for example, termites, some kinds of ants, and many insects including beetles, crickets, and flies that live in caves.

In addition to the large compound eye, many insects have smaller simple

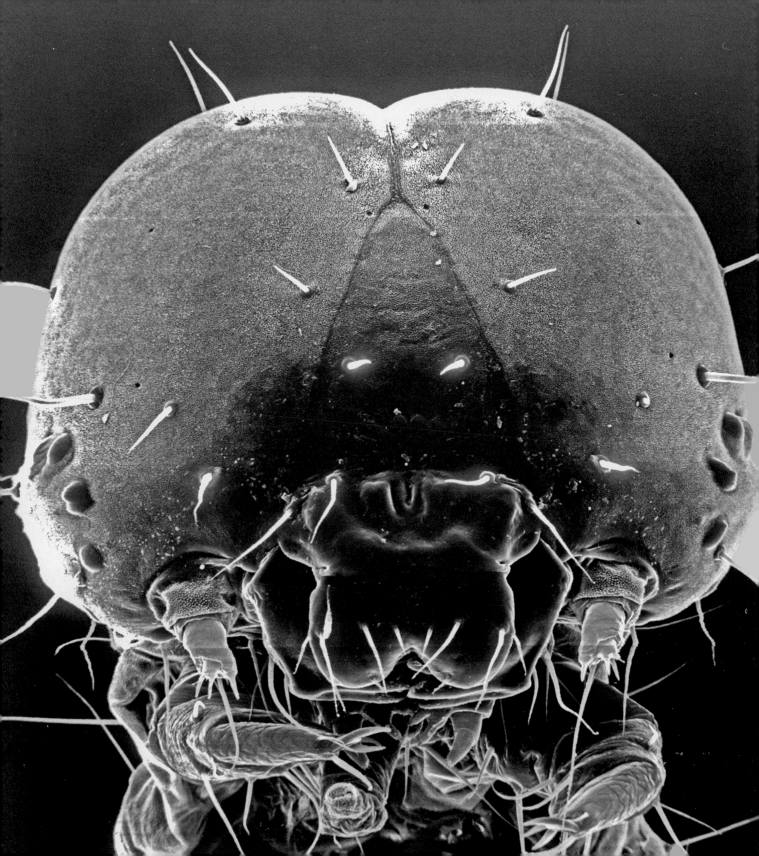

OPPOSITE Caterpillars generally have eight ocelli. They are visible on the lower outside of the caterpillar's head in this micrograph. Caterpillars may need only enough vision to distinguish night from day. Compound eyes, which can see images, may not be useful to caterpillars, since they are too slow to escape predators.

eyes called ocelli. Most insects have three ocelli positioned on the top of their head, although some species have only one or two. Some insects and insect larvae lack compound eyes but have ocelli. Ocelli can detect light, but they do not form good images. These simple eyes help flying insects to balance and orientate.

Insects are not the only arthropods with compound eyes. Crabs and their relatives (Decapoda) have compound eyes, which, in many decapods including lobsters, crabs, shrimp, and crayfish, are uniquely designed to intensify light. This is what these animals require, as there is very little light many feet under the sea or at the bottom of a muddy river. Rather than focusing images, as our eyes or the ommatidia of insects do, the facets of decapods' eyes act like little mirrors to intensify light. Unlike the compound eyes of insects, in which ommatidia are usually arranged in hexagonal patterns, the facets of decapods' eyes are organized in square arrays. Since the ability to intensify images has many practical applications, the eyes of decapods are of great interest to engineers and biologists.

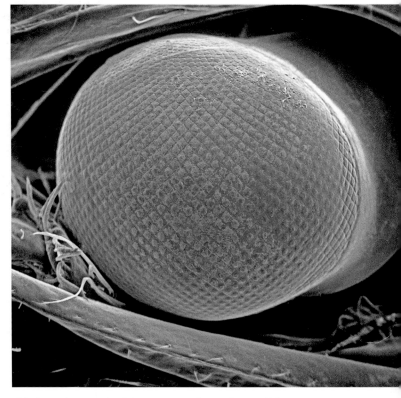

This is a micrograph of the compound eye of a crayfish (a crustacean, not an insect). The facets of the crayfish eye are arranged in square patterns. They act like tiny mirrors to reflect and intensify light, enabling the crayfish to see in murky water and very low light, conditions in which the compound eyes of aquatic insects are ineffective.

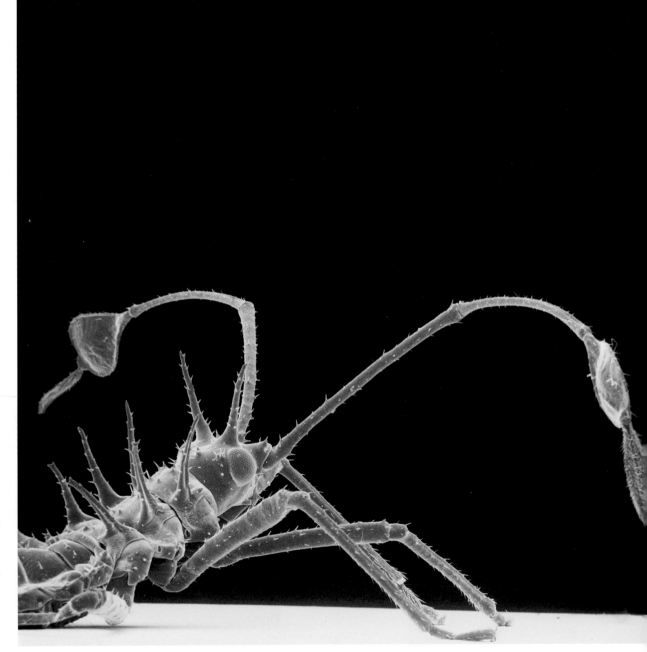

Relative to its size, the antennae of this insect are very large. Before rooftop antennae, cable TV, and satellites, television sets had "rabbit ears" antennae that could be adjusted to acquire the strongest signal. The antennae of this insect, which it probably rotates in order to detect minute amounts of certain volatile chemicals, look something like TV rabbit ears.

6 | antennae

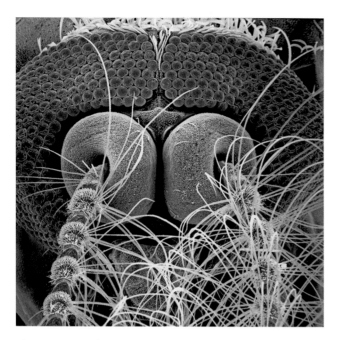

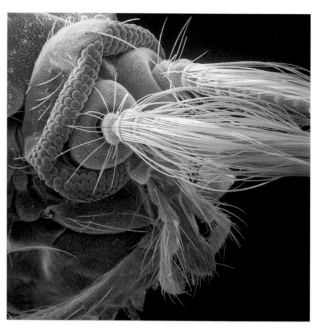

The antennae of this tiny fly are adorned with many hairs. The antennae of most insects can detect minute amounts of numerous volatile molecules.

Long hairs fray out from the base of this little fly's antennae. Sclerites at the base of enable the insect to rotate its antennae, which helps the fly to detect week chemical signals.

WE ARE AWARE that some dogs can follow the scent of a person through the woods and that hunters know to face the wind when they are stalking deer. However, because our sense of smell is relatively poor, we may not fully appreciate how important the ability to detect volatile molecules is to so many animals.

The large majority of the brain of most insects is devoted to processing information from their eyes or their antennae. Most of the brain of insects that see well, like dragonflies and house flies, is devoted to detecting information from their eyes. However, most insects do not have good vision. The majority of the brain of these insects is used to process information from their antennae. They rely on their sense of smell to communicate with others of their species and to detect the nature of their surroundings, including identifying food sources, danger, and mates.

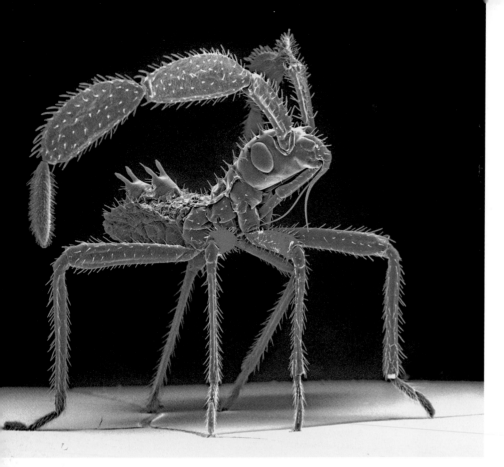

This nymph has very prominent antennae. Since it must be awkward and consume energy to carry around such large antennae, we can assume that the antennae have important functions.

The antennae of insects contain olfactory receptors that send signals to the brain when particular kinds of molecules land on receptors sensitive to them. The concentration of molecules in the air is highest at their source and less with increasing distances from that source. Insects use their antennae to follow concentration gradients of volatile molecules to find their source. Most female insects emit volatile hormones called sex pheromones. Males of the same species are able to detect the pheromones emitted by a female and follow the concentration gradient to her. For male insects that are uncommon in an area, finding a mate can be challenging. I can collect all spring, summer, and fall in the same general area and fail to find even one individual of some species known to inhabit the area. Males of these less abundant species nevertheless locate females by following gradients of sex pheromones. The antennae of some kinds of moths are

Many insects, like this wasp, have long, thread-like antennae. Some of the receptors on the antennae of flying insects detect wind velocity and direction. Consider a helicopter pilot landing in the wind. The pilot uses instruments to measure the wind velocity and direction in order to land safely. Landing is a similar challenge for a wasp, as it must correct for wind direction and velocity in order to land on a flower, leaf, or twig.

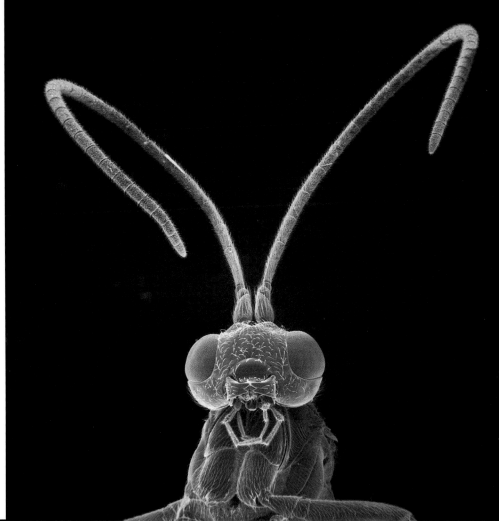

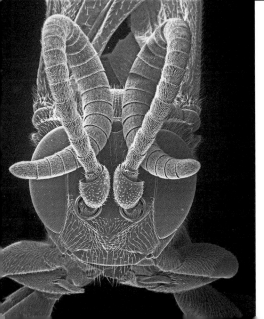

This is the head of a wasp. The antennae of wasps and most other insects are flexible because they are composed of segments that can articulate on one another. As is the case in the antennae of the wasp in this micrograph, there are also sclerites at the base of each antenna that act like a ball joint. Look closely at a yellow jacket the next time one visits your picnic table, and you will see that her antennae are constantly rotating and bending.

As a wasp walks along, its antennae sense numerous chemicals that reveal the nature of its environment. Not only can the wasp sense volatile chemicals in the air, but its antennae also detect chemicals on the surface of objects. Most solitary wasps lay their eggs on or in the body of an insect, or paralyze insects and bring them back to their nest to feed their young. Wasps that are selective about the kinds of insects they bring to their nests use their antennae to touch the animal in order to determine if it is appropriate food for their larvae.

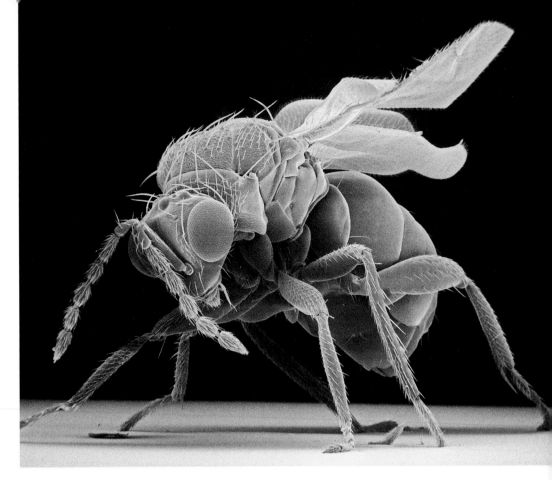

some of the most sensitive. Males are able to detect the sex pheromones emitted by a female moth a mile away.

After mating, females of some kinds of insects must detect aromatic molecules emitted by plants to find the appropriate plant species on which to lay their eggs. Female insects of some species need to lay their eggs on a particular species of plant because their young feed only on that kind of plant. Many parasitoid insects must locate a particular species of host on or in which to lay their eggs.

The beautiful perfumes released from flowers are not made for our enjoyment but rather to attract insects that come to the flowers to feed on them or collect their nectar and/or pollen. Pollen attaches to insect hairs. The insect then may transport the pollen to other flowers of the species where pollen, the botanical equivalent of sperm, fertilizes the ovum. In many species of plants the attraction

RIGHT TOP The antenna of a male midge (Chironomidae). Some male insects can detect pheromones secreted by a female thousands of feet away. This could mean detecting just a few molecules in the air and following a concentration gradient. The antennae that can do this have large surface areas and, in some insects, are reminiscent of a minuscule paintbrush or feather, as in this micrograph. RIGHT BOTTOM The architecture of antennae is extremely variable among insects. One reason for this is that a male insect needs to detect the unique pheromones emitted by females of his species. Following the scent of a female belonging to a closely related species would be a waste of time, and since most insects are short-lived and are subject to intense predation, males have a very limited time to find a mate. LEFT The antennae of this beetle resemble antlers. There is a great deal of variation in the size and shape of antennae among beetles, because different species of beetles need to detect different molecules. Females of a particular species of jewel beetle lay their eggs in trees that have been burnt by forest fires. Remarkably, these beetles can detect the odor from distant fires better than the most sensitive instruments of forest rangers.

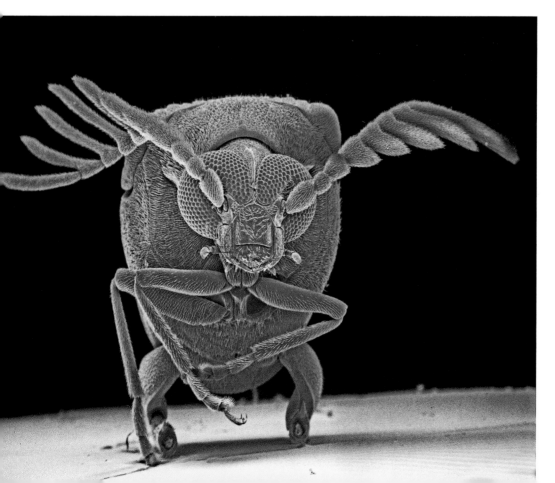

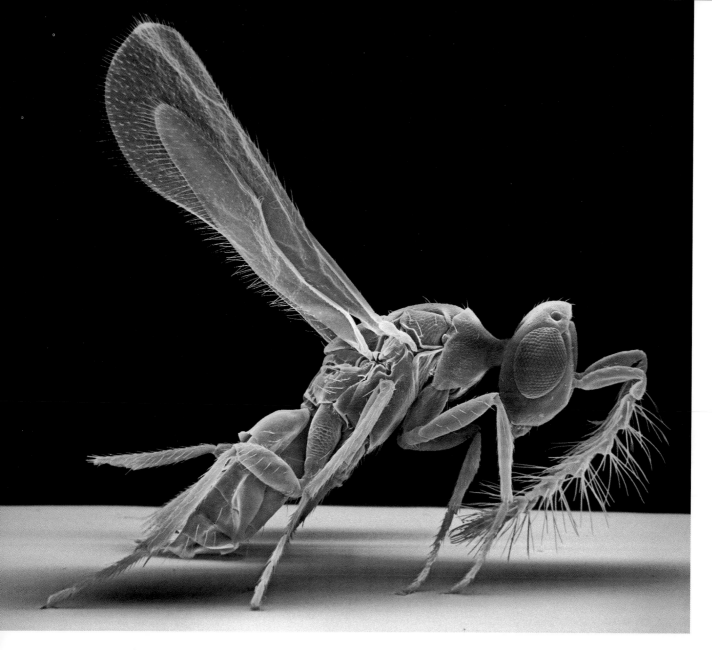

Most species of solitary wasps are parasites or parasitoids. (The distinction is that parasites usually do not kill their host, whereas parasitoids do.) For almost every insect pest there is a species of wasp that preys on it or its eggs. This parasitoid wasp was about the size of a pinhead. These tiny wasps may have only one appropriate host on or in which to lay their eggs. To determine if an insect is the correct host, the wasp may touch different areas of its body with her antennae to detect the molecules that identify the species of the insect.

is strong, as their flowers may bloom for only a few days or, in some species, like the daylily, only one day. Flowers tend to bloom on hot, sunny days, presumably because bees, flies, and other pollinators are present in greater numbers on those days. Many predatory insects also are attracted to flowers in order to find the insects they feed on.

Flowers are not the only part of plants that attracts insects. When they are attacked by insects, the leaves of some species of plants emit aromatic molecules that attract predatory insects. This symbiotic relationship is beneficial to both the plant and the predators. By attracting predatory insects, the plant gets rid of the insects that are eating it, and the predators obtain a meal.

Many insects that live in groups secrete so-called alarm pheromones, which warn others of their species that a predator is in their midst. Some

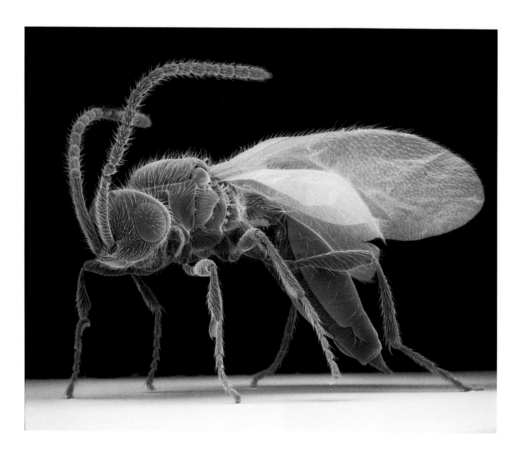

This is a primitive wasp called a sawfly (Tenthredinidae). The most important pollinators are bees and flies. However, many other kinds of insects including sawflies, wasps, beetles, butterflies, and moths are attracted to flowers and serve as pollinators.

male insects secrete pheromones to mark their territory, just as many male mammals mark their territory with scents. Insects also can secrete what are termed aggregation hormones, which attract others of their species; you may have seen hundreds of ladybugs all gathered in the same place. In addition, insects use their antennae to find food and water and probably things that have not yet been documented.

In many insects the antennae of males and females are dissimilar because they are employed to detect different volatile molecules. Mosquitoes are a good example. Female mosquitoes must locate an animal from which they can obtain a blood meal. In some cases, for example the *Anopheles* mosquitoes that transmit malaria, the female feeds only on primates (humans and monkeys). First, she uses her antennae to detect mammals. (She has the ability to sense heat and carbon dioxide given off through the mammalian skin using receptors in her antennae and other sense organs near her mouth.) Having found a mammal, the anopheles female must then distinguish between primates and other mammals. Unfortunately for humans, a female anopheles,

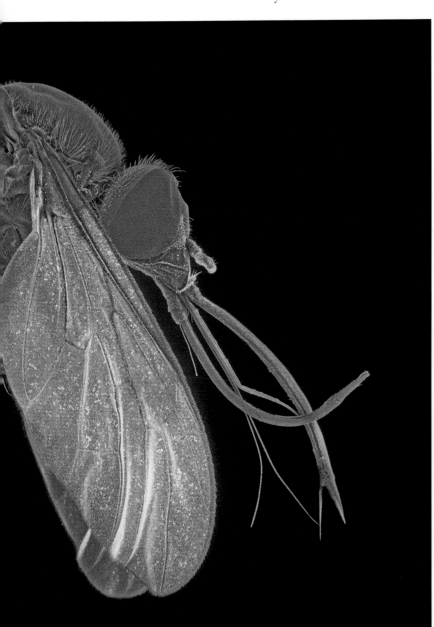

This micrograph shows the mouthparts of a female mosquito. Female mosquitoes need to find an appropriate animal to feed on, and subsequently they need to locate standing water, where they lay their eggs.

Long mouthparts and feather-like antennae can be seen in this micrograph of the head of a male mosquito (Culicidae). The plumose antennae of male mosquitoes enable them to find flowers and mates. Male mosquitoes do not bite. The long mouthparts are employed to reach the nectar most male mosquitoes feed on.

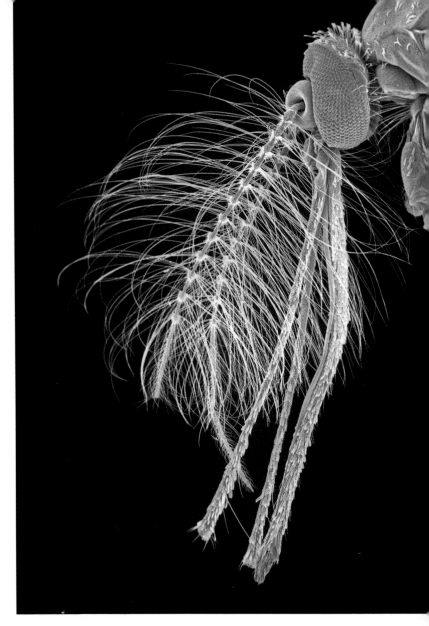

as well as other kinds of mosquitoes, may feed on more than one person, which is how mosquito-borne pathogens spread. After they feed and mate, female mosquitoes use their antennae to locate standing water, where they lay their eggs.

Unlike female mosquitoes, most males feed on nectar. They employ their antennae to find flowers and mates. The feather-like antennae of a male can detect pheromones emitted by females and also act as "ears" that enable him to hear the location of a potential mate from the buzzing sound females make when they fly. Detecting sound as well as scent may seem like too many different functions assigned to a single sensory organ, but mosquitoes are very successful. Unfortunately, pathogens including the protozoan that causes malaria, and the yellow fever and dengue fever viruses, use mosquitoes as a way to get injected into hosts. Experts fear that global warming will increase the problem, as the mosquitoes that spread these diseases thrive in hot, wet climates.

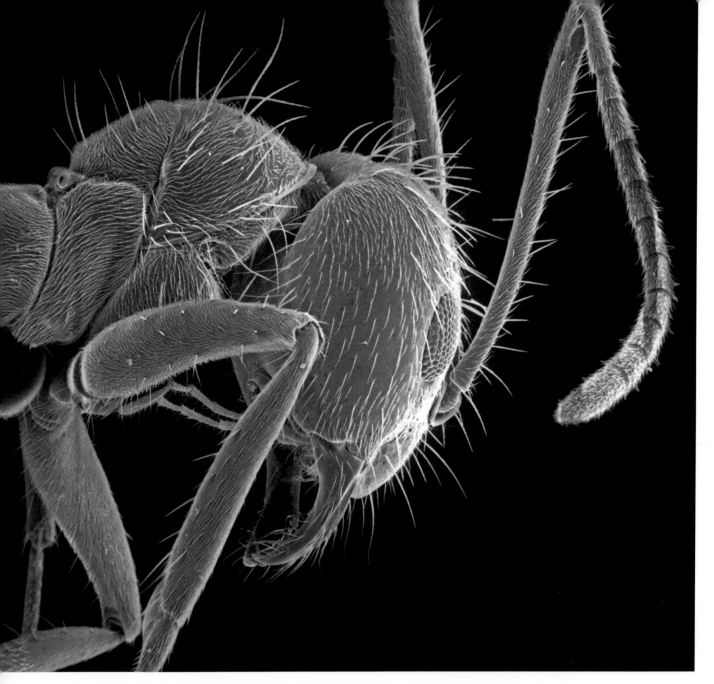

Note the sharp bend in the elbow-shaped antenna of this ant. Ants use their antennae to detect scent trails that have been made by other ants from their colony. They also communicate with one another by touching antennae. They literally keep in touch. Presumably touching antennae is effective, as ants cooperate very effectively in many tasks including building complex underground nests.

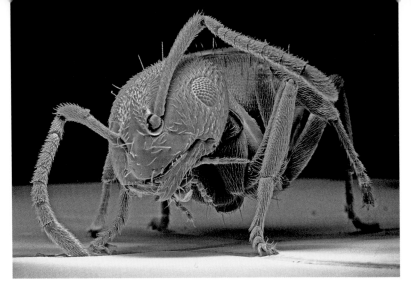
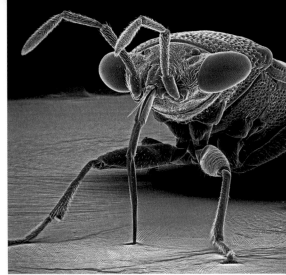

LEFT When they meet, ants use their antennae to determine if another ant of their species is from their colony. For some kinds of ants, straying into the territory of another colony can mean death if discovered. RIGHT Although this bug-eyed true bug can fly, like most Hemiptera, it usually travels by walking. As true bugs walk, they wave their antennae in order to touch everything in their path. Receptors on the antennae can detect numerous molecules. The molecules on the surface of a plant may indicate whether it is an appropriate species to feed on.

Antennae are sometimes called feelers. This is an appropriate term for the antennae of many insects, because they direct their antennae forward and move them back and forth in order to detect the nature of the objects they touch.

Ants have elbow-shaped antennae they hold in front of them and constantly wave back and forth as they feel their way through life. Elbowed antennae can fold back out of the way when

ants walk through the narrow tunnels where they spend most of their lives. They must negotiate these tunnels in total darkness. In addition, ants need to dig interconnecting tunnels and chambers. In fact, some ant species dig interconnecting tunnels that stretch for many miles. Other tasks conducted in total darkness include caring for and feeding larvae and the queen, cleaning the colony, storing food in the proper places and, in some species, farming

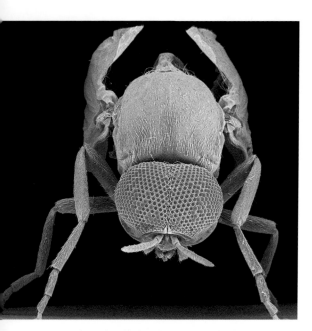

BELOW Ants must leave the safety of their underground homes to forage for food. The colony requires a lot of food, as ant larvae cannot feed themselves. Young adult worker ants (always sterile females) care for larvae and the queen. They also excavate and clean tunnels and chambers. It is usually when they are older, like the stooped-over old girl shown in this micrograph, when they begin to forage for food. It is theorized that older adults are more expendable to the colony than younger animals, because they have less long to live. These older ants thus take on the hazardous duty of foraging.

ABOVE This fly has big eyes and relatively small antennae. Species of flies that are speedy usually have small antennae. To a fly, keen vision is essential in order to avoid twigs, leaves, and other objects in its path as well as to evade predators. Most of their tiny brain is devoted to interpreting signals from their eyes. Thus, these flies trade off some of their sense of smell for superior vision.

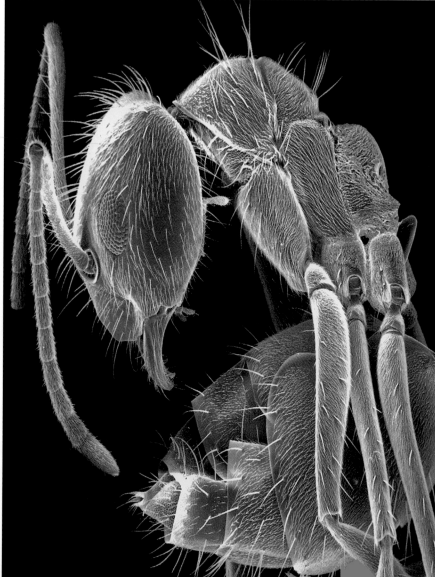

TOP In addition to ants, snout beetles, like this one, have elbow antennae. As the beetle inserts its snout into a seed through the hole it is making, its elbow antennae fold back.
BOTTOM This is a globular springtail (Collembola). Springtails are unusual insects in a number of aspects. In fact, most experts believe springtails are not insects but belong to a separate group of six-legged arthropods. The antennae of male globular springtails, which are larger than those of females, are employed to hold females during mating.

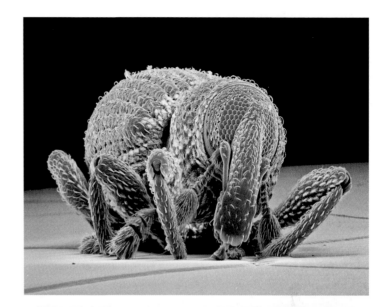

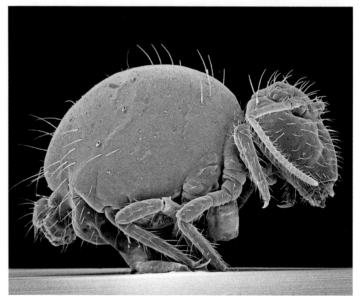

fungi. Ants come out of the ground to forage food. When they locate a food source, they can secrete a scent along their path back to their underground home. Other ants from the colony follow the scent trail to the food. Antennae play a critical role in all the tasks in an ant's busy life.

Although house flies originated in central Asia, they are found almost everywhere humans live. Because they are swift, house flies can cover a large territory. Pathogenic bacteria and viruses in dung and garbage that house flies feed on may attach to the flies. Among the diseases they transmit are typhoid, cholera, and hepatitis. Fortunately, most of these diseases are uncommon in the developed world, so house flies are not such major health threats in developed countries. House flies and related species have small antennae. They depend more on visual rather than olfactory signals, and most of their small brain is devoted to vision. Another reason for having small antennae is

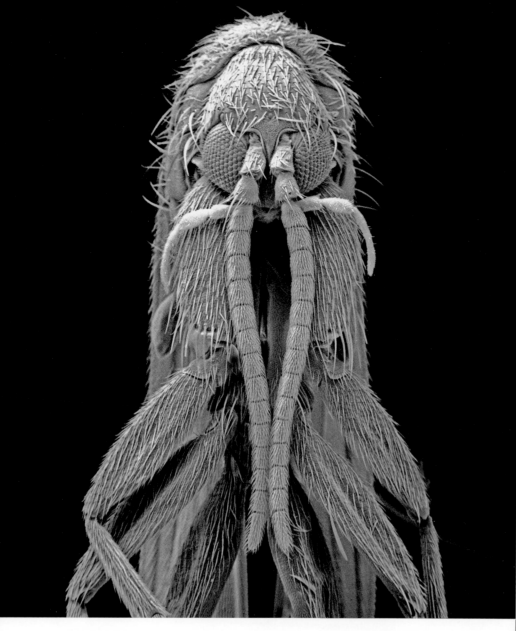

This micrograph of a wasp viewed from below shows palpi in a good position to determine if a potential food is palatable. Palpi are usually much more prominent in arthropods that are related to insects. Spiders have prominent palpi that are adorned with sensory hairs. In addition to sensory organs spiders use their palpi like little arms and hands. The palpi of scorpions are their claws or pinchers.

ABOVE Palpi can be seen on either side of the mouth of this female midge. They look something like a mustache. In addition to sensing food, palpi have receptors that can detect numerous other molecules.

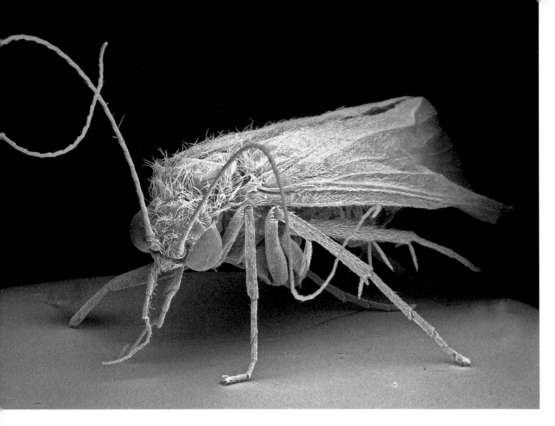

Prominent palpi can be seen below the head of this caddisfly. Although caddisflies have prominent palpi, most adults have vestigial mouthparts and do not feed. This suggests that the palpi of caddisflies have sensory functions not related to eating. Caddisflies look like moths and, like moths, they are attracted to lights. Instead of scales the wings of caddisflies are covered with hairs. Because caddisflies have aquatic larvae, which in many species live in fast-moving clear water, both adults and larvae are a major source of food for trout. Trout fishermen frequently use flies designed to resemble adult caddisflies.

that if their antennae were large, they might be too cumbersome for acrobatic flight.

Some species of insects use their antennae for courtship or mating. For example, males of some kinds of cockroaches caress females with their antennae in order to encourage them to mate. Some male long-horned beetles grasp females and hold them with their large, strong antennae during mating. Globular springtails, tiny six-legged arthropods, also use their antennae for mating. The male globular springtail grasps the female's antennae with his. The female then holds him in the air and positions him for mating.

Although antennae are the primary sense organs, insects may have chemical sensing hairs (setae) and other sense organs in other locations of their bodies, particularly on tiny, arm-like extensions called palpi or palps, which are situated adjacent to the insect's mouth and are associated with taste. When insects taste food, the palpi typically vibrate rapidly. The process is termed palpation.

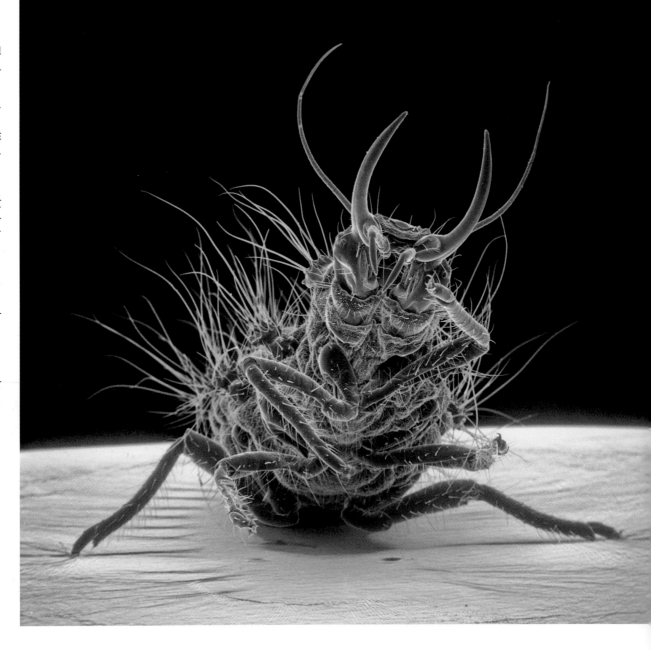

The large, pincerlike jaws on this hairy neuropteran larva are used to spear small insects, mites, and other arthropods.

7 | mouthparts

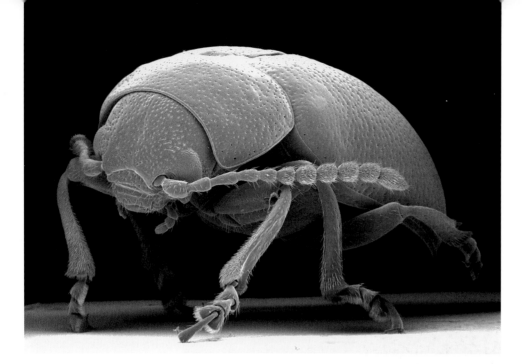

Many kinds of beetles and their larvae use their mouthparts to chew wood. Beetles and beetle larvae that feed on dead wood on the forest floor are beneficial as they help to recycle nutrients. On the other hand, beetle larvae that eat living trees are a tremendous problem. One of the most hazardous is the Asian long-horned beetle. Unlike the larvae of some wood-eating beetles that feed on only one or two kinds of trees, Asian long-horned beetle larvae feed on several kinds of trees including maple, birch, and chestnut. Trees that become infested ultimately die. The beetle was imported from China, presumably on wood that was used in packing materials before the problem was recognized and packing materials were required to be treated. The beetle was first found in New York City in 1996, and there have been infestations in the Northeast and Midwest.

THE MOUTHS of insects are composed of a number of parts, which exhibit markedly diverse shapes and arrangements in different kinds of insects, depending primarily on how the particular insect feeds and what it feeds on. The diet of insects varies from everything we would consider edible to many things we would not eat, including other insects, mites, spiders, wood, dung, and decaying plants and animals. Some insects, such as cockroaches, have a varied diet that includes virtually everything we would eat and more. Other insects have limited diets consisting of only one part

The sharp-pointed, pincer-like jaws of this larval neuropteran are designed to pierce the cuticle of small insects and mites and hold them firmly. The jaws of many neuropteran larvae also have a groove through which they secrete molecules that paralyze and kill their victims.

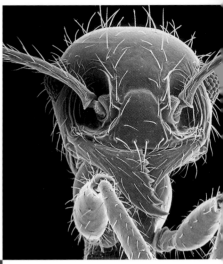

The right mandible of this ant can be seen in front of the left one. Insect mandibles move from side to side rather than up and down like our jaws.

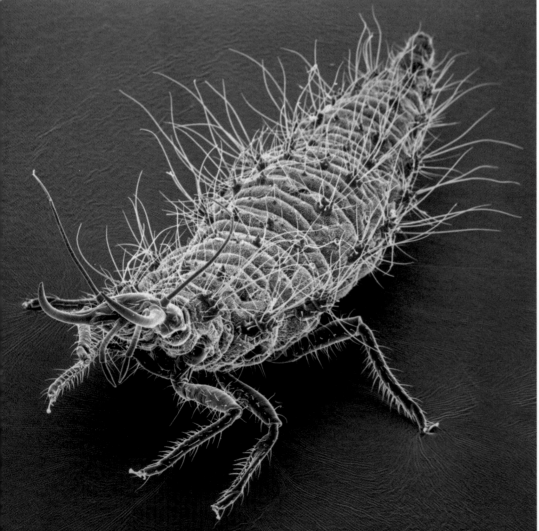

of a particular kind of plant or the blood of one group of animals. Some insects chew their food whereas others ingest only liquids. In addition, some insects may use their mouthparts for defense, digging, carrying, and construction of various nests and shelters.

Many insects have mouthparts designed for cutting and chewing. Mandibles of these insects are somewhat like jaws, but they cut and chew from side to side instead of up and down like our jaws. The mouthparts of ants are a good example. The mandibles of ants bear pointed processes that fit together and function like teeth. In addition to their function in chewing, mandibles of many insects are used to bite. The bite of some kinds of ants is especially painful because these species don't just bite but also spray acid and other irritating chemicals from their abdomen into the wound they have made. Ants have the ability to bend their abdomen underneath them so that the back of their abdomen is adjacent to their mouth. With their abdomen in this position some species of ants can squirt toxic chemicals directly into the wound from a tube-like structure at the rear of their abdomen. Fire ants are particularly nasty.

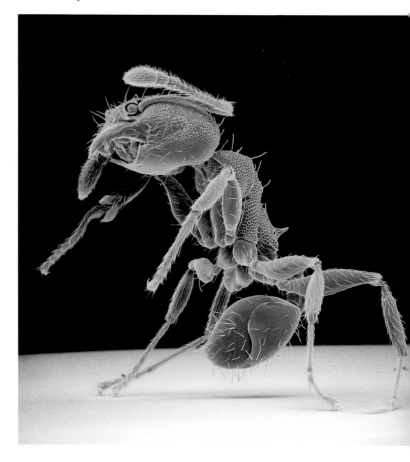

Although ants use their mouth to bite, they also used their mouthparts to dig tunnels and chambers and for delicate operations such as picking up and moving eggs and larvae and grooming their queen. This is a sterile female ant. I am confident of the gender because all wingless ants are sterile female workers. As can be seen in this micrograph, the segments between this ant's thorax and abdomen permit the abdomen to move forward so that the back of the ant's abdomen is adjacent to her mouthparts. The modified ovipositor of worker ants of some species can spray acetic acid and other toxic chemicals into the wounds they inflict with their mandibles. The pain that is felt when these ants bite is primarily from the toxic chemicals rather than the wound itself.

This is a kind of cricket. Crickets are well known for their loud summertime chirping. Many insects "sing" to attract mates, but they do not employ their mouth to make sounds. Instead, sound is generated by rubbing various body parts together.

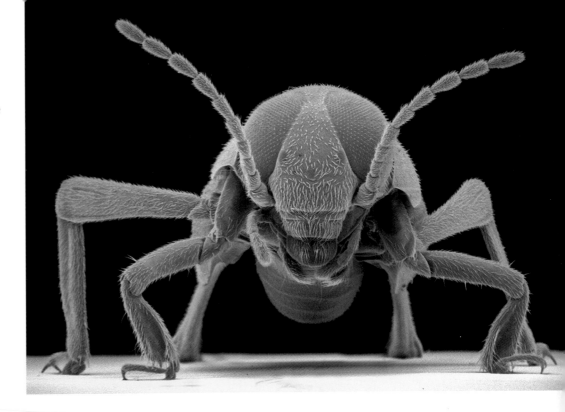

They get their name because it feels like you are on fire if you are bitten by a lot of them. They are common in the southern United States and are so formidable that in fields where there are large colonies of fire ants there are very few small rodents. Fire ants have killed and eaten them.

The mouthparts of some insects, such as grasshoppers and crickets, are used for chewing food. Unlike ants, these insects do not bite. Although many insects have a restricted diet, most grasshoppers and crickets eat many grasses including wheat and other grains.

The mandibles of snout beetles or weevils (Curculionoidea) are located on the tip of the beetle's long snout. Typically, female snout beetles use their mandibles to gnaw holes through seeds or nuts. The beetle then turns around, inserts her abdominal tube-like structure called an ovipositor through the hole, and lays her eggs. The seed now serves as both a safe haven and food source for the weevil's larvae. Generally females of each species of snout beetle lay their eggs in the seeds of only one kind of plant. Unfortunately the plant species include many important crops, such as rice and wheat.

This weevil's mandibles can be seen protruding from the end of its snout. These sharp mandibles enable weevils to gnaw holes through seeds. Having bored a hole in a seed, the female weevil inserts her ovipositor in the hole and lays her eggs.

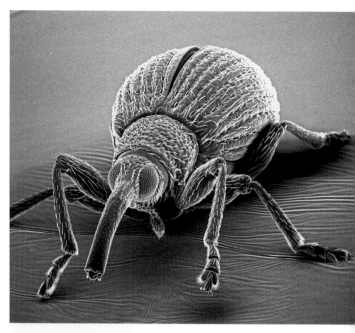

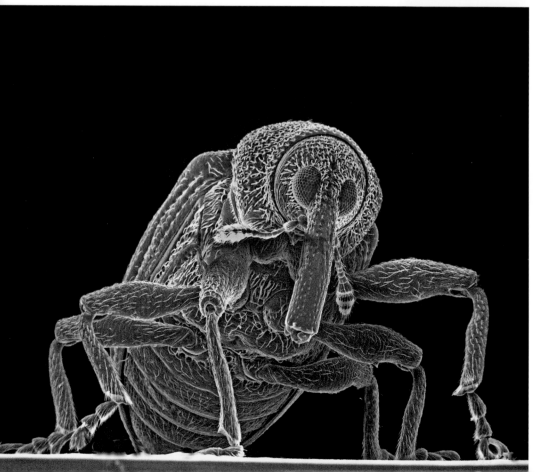

The elbow-shaped antennae of snout beetles can fold back out of the way when the beetle inserts its snout into a seed. When threatened, a number of kinds of insects, including many kinds of snout beetles, fall to the ground and do not move. It is difficult for many predators to find insects that are motionless.

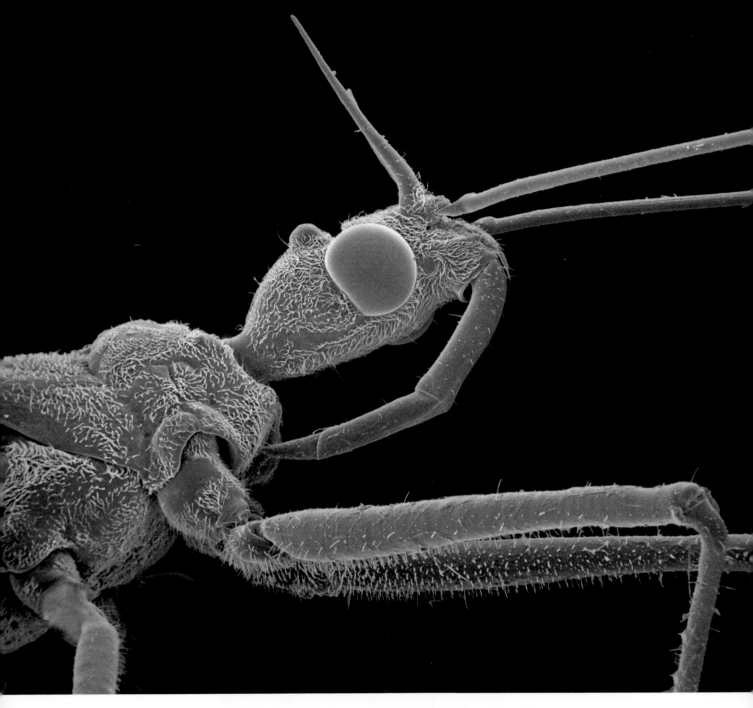

Unless they are feeding, the beaks of true bugs are tucked under their heads, as they are in this specimen. The true bug can swing its beak out during feeding. Beaks serve as sheaths that protect the delicate stylets (piercing and ingesting mouthparts) when bugs are not feeding.

The larvae of net-winged insects (Neuroptera) have unusual mouthparts. Adults look like dragonflies, although they are not related. They usually don't feed and have only vestigial mouthparts. On the other hand the larvae are voracious carnivores. One of the most interesting net-winged insect is the ant lion. The name ant lion comes from the larvae, which have large jaws formed from fused mouthparts they employ to catch and kill ants and other small insects. Ant lion larvae dig funnel-shaped traps in sand or dirt to catch much faster-moving insects. They construct their pitfalls by walking backward in the sand or loose soil in smaller and smaller circles. The ant lion larva then burrows itself at the bottom of the trap with only its jaws exposed. A little insect that slides into the trap is promptly stabbed by the ant lion's sharp jaws and eaten. The body of the ant lion is covered with long hairs that serve to hold it in place as it tussles with its prey and beats it against the sidewalls of the funnel-shaped trap. Some species of ant lions toss sand up when they sense an insect fall into their trap. The flying sand causes the insect to slip to the bottom of the trap, into the waiting jaws of the ant lion.

There are many animals that eat only liquids, including spiders and their relatives and many kinds of insects. Many species of flies, including the house fly, feed exclusively on liquids. In order to gain the nourishment from solid food, these flies first regurgitate liquid containing enzymes that liquefy the food. They then lap up the liquid.

In the insect world, there is a large and diverse group (order) of insects called Hemiptera, generally referred to as true bugs. The delicate, thin mouthparts of true bugs, referred to as stylets, are protected by a sheath-like beak or rostrum when the bug is not feeding. Most kinds of bugs feed on plants, but some feed on other insects, amphibians, reptiles, and mammals, including humans. When a true bug feeds, it opens its beak lengthwise, exposing the four long, thin

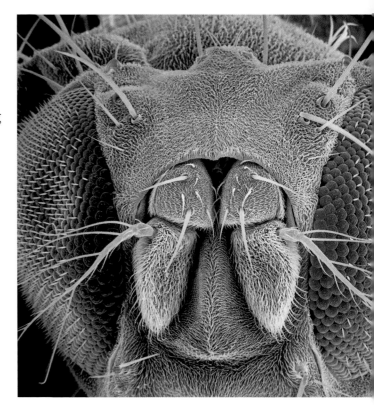

This micrograph shows the front of a fly with its mouthparts retracted. House flies as well as many other kinds of insects feed exclusively on liquids.

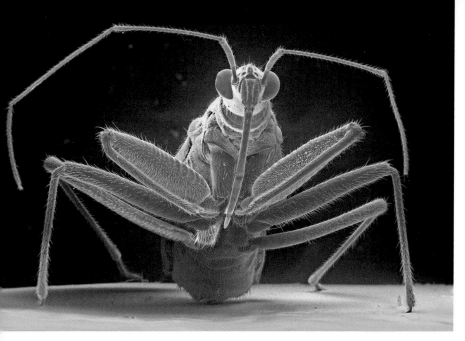

This is an assassin bug (Reduviidae). The powerful front legs of assassin bugs are employed to hold prey while they are paralyzed or killed and their internal organs dissolved and ingested into the bug's digestive tract. Although many kinds of assassin bugs feed on insects, in Central and South America some species feed on human blood. These assassin bugs are responsible for infecting people with a trypanosome, the single-cell organism that causes Chagas' disease. Most people who are infected live in poor rural areas where it is relatively easy for the bugs to enter simple dwellings and people are so used to insects that they may not be aware of the danger. We don't hear much about Chagas' disease, because it occurs only rarely in the southern United States. However, some ten million people in South America are infected, and most of them don't know it. The symptoms are mild at first and soon abate. However, with time the disease can cause damage to the heart, intestines, and nervous system and can be fatal. The available drug treatments are highly toxic and often ineffective, particularly by the time a patient develops severe symptoms.

stylets. The front two stylets puncture the plant or animal. The rear two stylets are coupled together to form a long, narrow tube the bug inserts into the puncture. True bugs that feed on plants inject a liquid containing enzymes that dissolve plant tissue into the puncture. Next, the bug ingests the liquefied tissue back into its digestive tract. This process may be repeated several times in order to liquefy and take in more food. When the bug is finished with its meal, it withdraws its delicate stylets into the longitudinal opening in its beak and goes on its way. True bugs that feed on vertebrates inject anticoagulants into the puncture they have made before ingesting blood back into their digestive tract, whereas true bugs that feed on insects inject chemicals that paralyze the prey and liquefy tissues before ingesting hemolymph, the insect equivalent of blood, containing liquefied organs into their digestive tract.

We think of bedbugs, which are

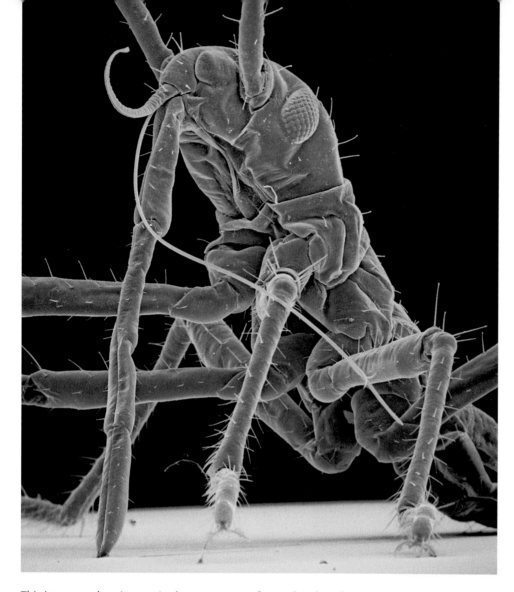

This immature hemipteran is about a quarter of an inch in length. True bugs open their beaks lengthwise; a microscopic stylet can be seen protruding from this one's beak. After a plant or animal is punctured, a true bug injects enzymes, toxic molecules, and/or anticoagulants into the underlying tissue. Subsequently the liquid diet is ingested into the true bug's digestive tract through a hollow tube formed by the rear two stylets. Some true bugs feed on other insects. After piercing the exoskeleton with its stylets, the true bug injects chemicals that paralyze the prey and enzymes that dissolve the insect's organs. Although being killed and having your insides ingested sounds painful, pain receptors have not been identified in insects, so they may not experience pain as we do.

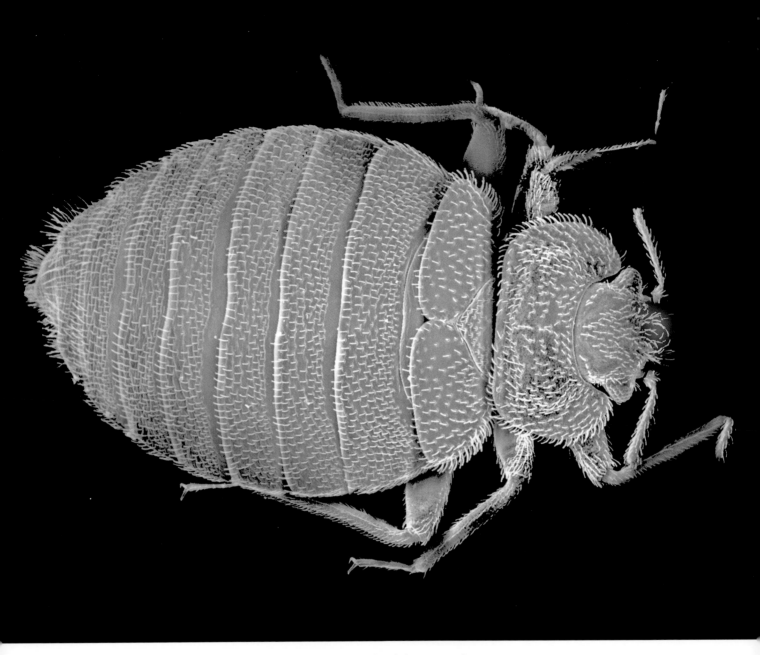

This bedbug (*Cimex lectularius*) has a large abdomen. The abdomen needs to expand a lot to accommodate enough blood in one meal to allow an immature bedbug to molt or for eggs to mature in an adult female.

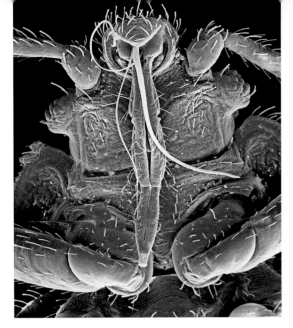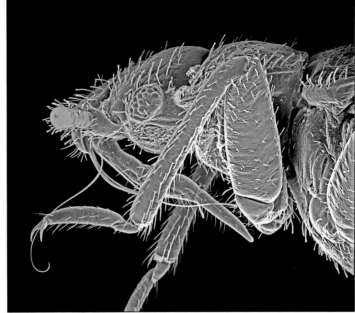

LEFT This bedbug is viewed from underneath. The two slender piercing stylets and a hollow stylet through which the bedbug feeds protrude from the lengthwise opening in the bedbug's beak. Bedbugs are expert at obtaining a blood meal without waking their host.

RIGHT Stylets can be seen protruding from the beaks of this bedbug. The two thin stylets are used to puncture the skin of the bedbug's host. The larger stylet is used to ingest the blood meal into the bedbug's intestine. Bedbugs have tiny eyes with just a few ommatidia. Although they probably can't form much of an image, the eyes enable bedbugs to determine that it is night, and time to hunt for a blood meal.

Hemiptera, as insects that live in filthy places. Unfortunately, no one seems to have told this to the bedbugs, as they can frequent five-star hotels. Bedbugs have become more common in the United States in recent years. There is speculation that before the insecticide DDT was banned, the liberal use of it kept bedbug populations at bay. There is also conjecture that bedbugs are more common because people use traps instead of insecticides to rid their homes and apartments of cockroaches. The insecticides that kill cockroaches also kill bedbugs, but cockroach traps are ineffective against bedbugs, since bedbugs are not attracted to scents that draw cockroaches.

Adult bedbugs are only about a quarter of an inch long. They hide during the day in cracks and crevices, and they are very difficult to get rid of. The saliva of

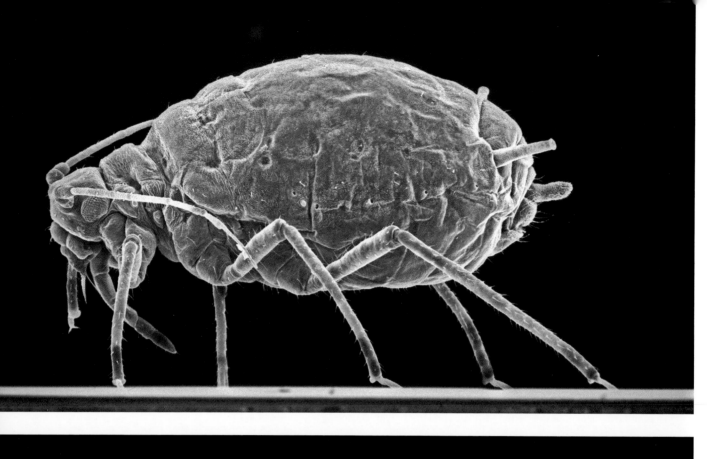
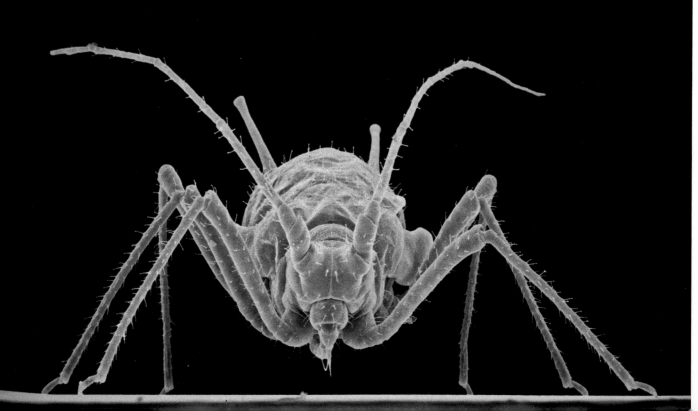

This chubby little insect is an aphid. Note that it has a small beak. Unlike true bugs, whose beaks extend from the head, the beaks of aphids emanate from the anterior of the thorax and cannot be swung out in front of the aphid. However, aphids are able to locate the tissues that carry liquids in plants and tap directly into them. Some species of aphids feed on a single plant species. You will often see a field of the same kind of plant covered with countless aphids in different stages of development. You may wonder how these little soft-bodied, slow-moving, and often wingless insects can escape being eaten by predators. The answer is that they are eaten, but aphids can go through so many generations in a season that they reproduce faster than they are consumed by predators. This is another aphid. Aphids can harbor plant pathogens that may have disastrous effects on civilization. In the nineteenth century the Irish Potato Famine resulted in the death of a million people. The fungi that killed the potato plants were spread by aphids.

bedbugs causes the bites to itch and, like any small wound that itches, they can cause welts and become infected if they are scratched. Although bedbugs are not usually considered to be disease spreaders, there is a recent report that they may carry pathogenic bacteria. Even if they do not transmit disease, it is extremely disconcerting for parents to know that bedbugs are biting their children. Having to pay an exterminator to come around several times and spray poison in your child's room isn't much fun either. Some exterminators use dogs that can locate bedbugs in their hiding places by their scent.

Aphids are little insects that can destroy houseplants, gardens, and crops. They use their beak to ingest the juices of plants. Aphids and their close relatives excrete a sugary substance from their anus called honeydew, which they synthesize from the juices of the plants they eat. Honeydew is an important food source for many kinds of insects, especially ants. Ants keep and protect aphids much as farmers maintain livestock. When winter comes, the ants carry their aphids' eggs into their underground nests and protect them until spring, when the eggs hatch and begin to mature. Then the ants carry their young aphids to a suitable plant, where they protect them and feed on the honeydew the aphids produce.

Both male and female fleas (Siphonaptera) feed exclusively on blood. Unlike Hemiptera fleas have

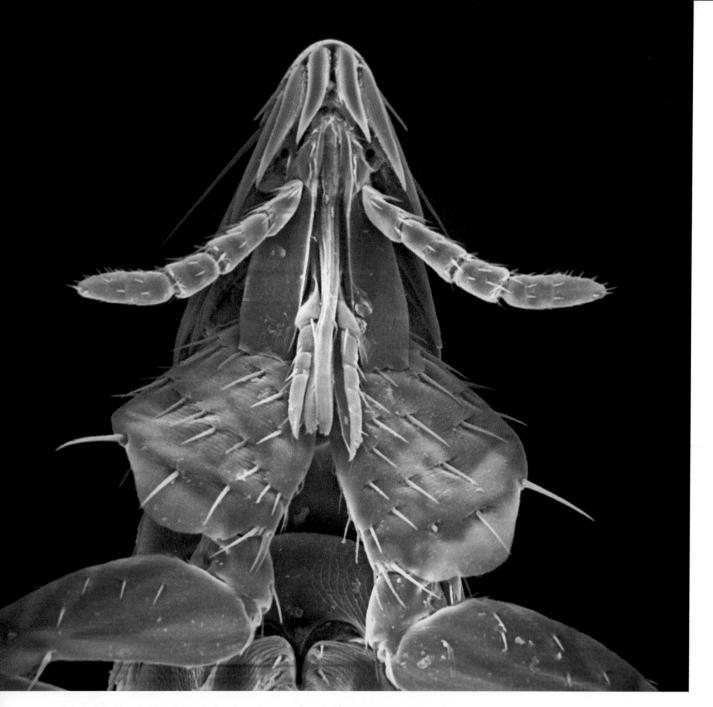

The underside of a flea's head showing the mouthparts that cause tiny wounds.
The lesions caused by fleas are small, so unless the flea's stylets hit a nerve, the flea
will probably go unnoticed by the host.

mouthparts that are not modified into a tube-like structure. Instead, their unique mouthparts are designed to create small punctures and subsequently ingest blood up from the wound. Within the flea's head there is a structure that functions something like a slingshot. The rubbery part of the organ that provides power is made primarily of an elastic protein, resilin; the same protein accounts for the elastic, flexible cuticle of fleas and lice that makes them resilient and difficult to crush. The slingshot-like resilin in the flea's head is attached to a hammer-like structure that is attached to stylets. When the flea finds a suitable spot to bite, it presses the front of its head against the skin of its host. Muscles pull back the resilin membrane and release it such that the force of the membrane on the hammer drives the stylets into the skin. This is repeated until blood flows. The flea then ingests the blood.

Thrips have unique mouthparts. These insects feed in a way similar to that of fleas: they puncture a tissue and then ingest fluid from the wound. Although there are species that feed on fungi and small arthropods, most thrips feed on plants. The single mandible of thrips, which is shaped something like a microscopic saw, is used to cut soft parts of plants. Hollow stylets are inserted into the puncture to force up the fluid with the aid of a pump-like structure in the thrips' head.

Termite colonies contain young animals, workers, soldiers, reproductive individuals, and queens. Solders are charged with protecting the colony. In temperate regions soldiers have large mandibles they use to defend the colony. However, soldiers are often no match for ants, the termite's worst enemy. Although termite soldiers have large mandibles and hard heads, their thorax and abdomen are soft

In this side view of the head of a flea, mouthparts are visible in front of the first pair of legs. When fleas bite, they lift their abdomen so that their mouthparts are pressed against the skin of their host. Next, the flea uses its sharp mouthparts to puncture the skin. The flea then ingests blood from the wound into its digestive tract.

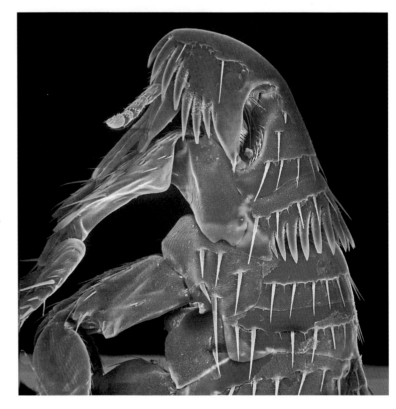

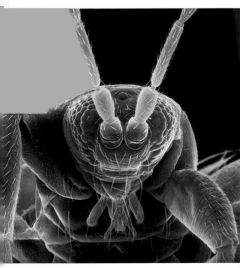

The mouthparts of this tiny thrips can be seen under its head. These strange-looking mouthparts are used to penetrate plants and pump up plant juices. Unfortunately, thrips often occur in massive numbers and destroy important crops. In addition to the direct damage, thrips transmit viruses that infect a number of crops.

This fearless nasuti soldier termite lived in a giant termite mound in Australia. These soldiers spray sticky, toxic fluid at intruders through their nozzle-like mouthparts. Although termites live in every state in the continental United States, most species live in the Deep South, especially Florida. Most species are not native to the United States but were introduced in wood that was transported in ships.

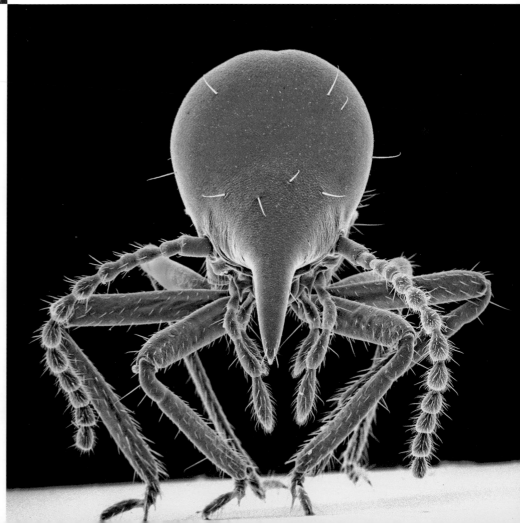

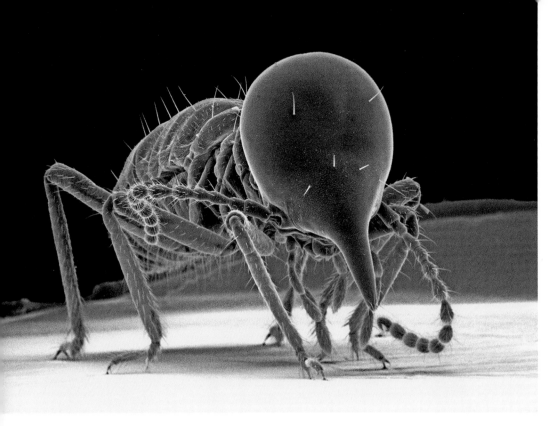

Although termites are soft-bodied insects, the head of soldiers is much harder than their thorax or abdomen. The nasuti soldier guards the termite mound and the queen. Termite workers constantly feed, protect, and pamper their queen. She returns their affection by surviving many years and, in some species, producing millions of offspring.

and relatively easy to penetrate, whereas the thorax and abdomen of ants have hard exoskeletons.

In semitropical and tropical regions some soldiers, called nasuti, have a unique means of combating ants and other predators. The mouthparts of nasuti soldiers are composed of a frontal projection. When the colony is attacked, the nasuti rush to the point of attack and spray a sticky, toxic substance on the attackers through their unusual, nozzle-like mouthparts. The sticky substance effectively immobilizes and kills insects, including ants. Thanks to the nasuti soldier, some species of termites are able to defend giant mounds that may house millions of termites.

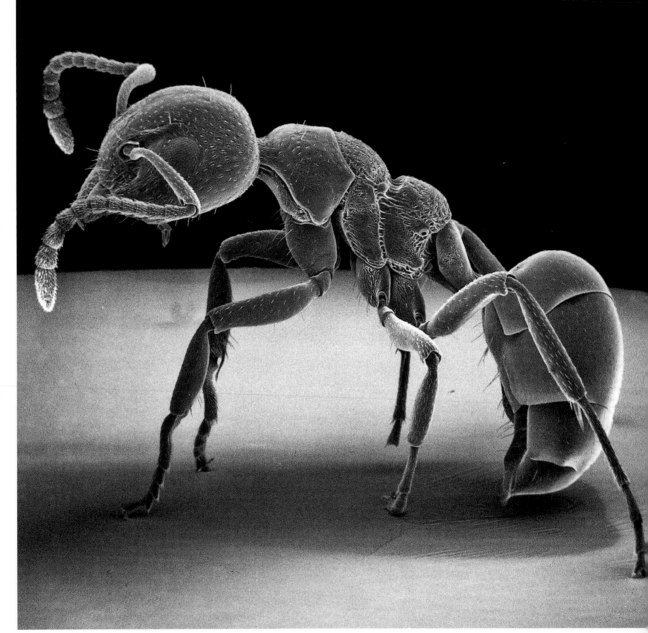

The insect thorax is composed of three segments. However, the individual segments are usually not obvious, because wings or a large sclerite, the notum, cover the thorax. This wingless ant is exceptional because the three parts of the thorax can be discerned, each with a pair of legs.

8 | thorax

TOP LEFT In many flying insects, like this wasp, the rear two segments of the thorax, which contain the two pairs of wings, are fused together. This protects the thorax from the force that is generated when the wasp flies. TOP RIGHT In most insects, like this snout beetle, a single large somite, the notum, shields the top of the thorax, so the three parts of the thorax are not apparent. BOTTOM LEFT In some insects the notum extends from the thorax forward over the head. In this micrograph of a lace bug (Tingidae) the insect's head can be seen just below its large notum. BOTTOM RIGHT The notum can be seen over the abdomen in this micrograph of a treehopper (Membracidae). The notum of treehoppers is shaped like a thorn for camouflage.

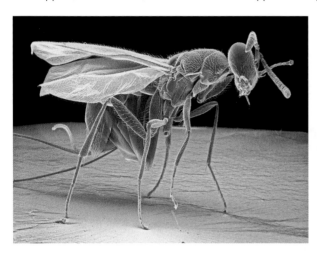
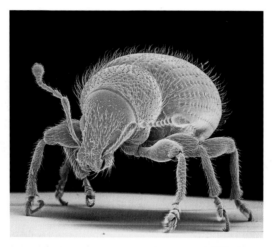

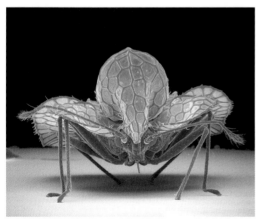
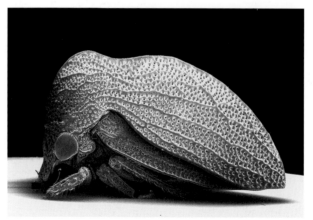

THE THORAX is situated between the head and the abdomen. It is composed of three segments, each with a pair of legs. A pair of wings is attached to the second and third segments. The demarcation between the three segments is not apparent in many insects, because the thorax is covered with wings or a single large sclerite called the notum.

Each of this insect's six feet has two opposable claws that can dig into stems and leaves. Claws enable insects to walk straight up on the stems of plants and to cling to leaves when they blow in the wind.

9 | legs and feet

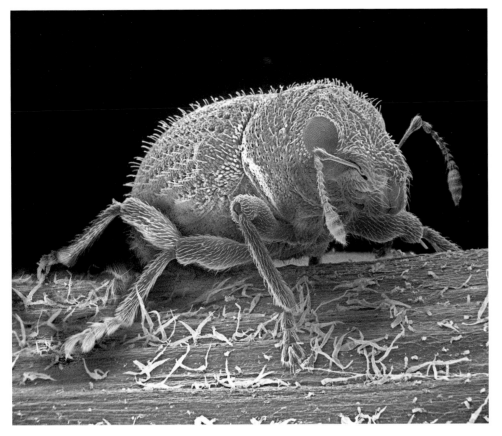

LEFT Next time you see a good-size beetle walking on a log, try to knock it over with a little stick. The claws of the beetle's feet dig into the wood with such tenacity that it is usually difficult to tip the beetle over. Pads on the beetle's tarsal segments also help the beetle cling to the log. If you attempt to gently pick up the beetle, its feet seem to be glued to the log. BELOW The numerous minute hairs that can be seen on the bottom of this house fly's foot allow it to walk upside down. Hairs above this fly's foot are sensory setae.

THE FEET of many kinds of insects each have a pair of sharp claws. Because they are opposable, like our thumb and fingers, insect claws can dig into plants for better footing. In addition to claws many insects have pads on their feet that help them gain traction on smooth surfaces. Pads, for example, enable house flies to walk on windows or upside down on ceilings. Most footpads have thousands of small hairs that fray out like a paintbrush into even smaller hairs. The surface of each microscopic hair has a molecular layer of water. The forces between the water layer on the hair and the surface that the insect is on, called van der Waals forces, temporarily bind the footpad to the surface. The segments of the leg next to an insect's foot, called tarsal segments, allow an insect to rotate its foot in order to obtain a better grip, somewhat similar to the way the tarsal bones in our ankles and feet enable us to rock our feet as we walk or run. With their opposable claws,

This snout beetle is lifting its right foot to demonstrate the tarsal segments that allow it to rock its foot and to cling to whatever it is walking on. Insects need a lot of flexibility in their feet, as they walk on very uneven surfaces.

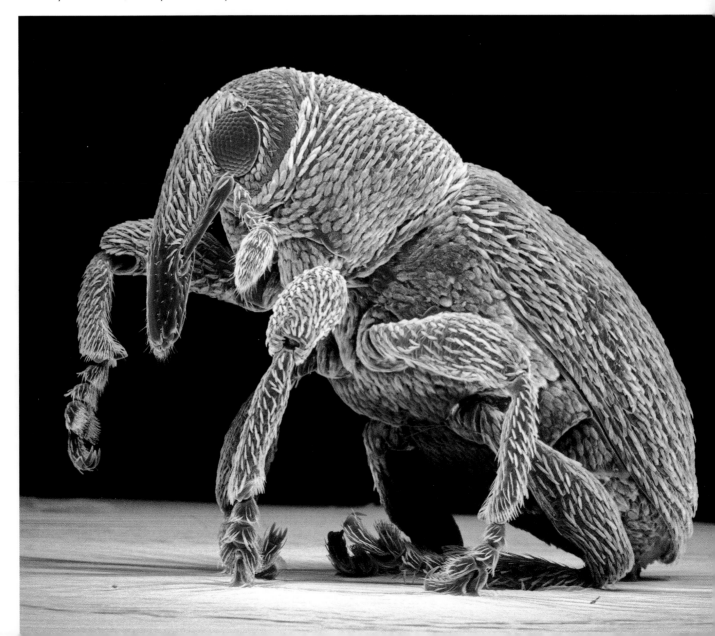

The ball-and-socket joints of the hind two pairs of legs near the thorax can be seen in this micrograph of an ant. These joints facilitate movement primarily from side to side. Two-dimensional movement prevents the ants' legs from wobbling.

pads, and flexible tarsal segments, insects have marvelous feet that have served them well for over two hundred million years.

The leg bones of humans and other mammals have joints that are designed to move primarily in two dimensions, forward and backward. Movement in just two dimensions keeps the legs of mammals from wobbling when they walk or run. In a similar manner most of the segments that comprise the exoskeleton of insect legs move in two dimensions. Because insect legs protrude to the side when at rest, the two directions are usually from side to side instead of forward and backward. The segments of the insect's leg nearest the thorax have the equivalent of a ball-and-socket joint that enables the insect to swing its leg around somewhat like how our shoulder joints can swing our arms around. When an insect

walks, it moves the two longest segments of its legs in a two-dimensional plane while it swings its legs from its thorax. Lizards and alligators have a somewhat similar gait.

Insects need to move each of their six legs independently for many aspects of their lives, just as mammals need to move each of their four legs separately. However, like mammals, when they walk or run, insects have a stride. Mammals usually move two of their legs more of less together as they walk or run, although they may have different strides depending on whether they are walking, trotting, or running. Many insect species also exhibit different strides. However, most insects usually move their front and rear leg on one side together with their middle leg on the other side. When those three feet are on the ground, they move their other front,

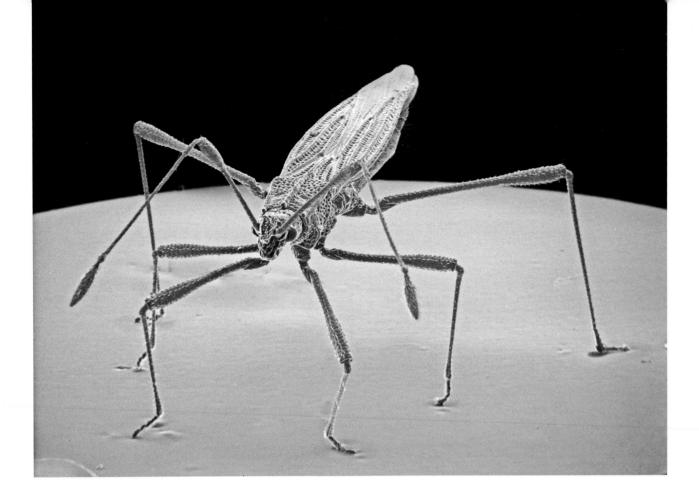

This is a stilt bug (Berytidae). Most kinds of stilt bugs are about a quarter to a half inch in length. They live and feed on plants. Although they walk slowly and usually do not fly, their long, slender legs enable stilt bugs to step from one leaf or stem to another.

rear, and middle legs synchronously. In this way insects always have their front and rear foot of one side and middle foot of the other side on the ground at the same time. This gives them the same stability as a tripod or a three-legged stool.

Whether an animal has two, four, six, eight, or more legs, if it runs its legs need to be roughly the same length. If its legs were different lengths, they might cross or get tangled up, and the animal would trip. This is why rabbits and kangaroos must hop rather than run. The back two legs of some insects are much longer than the two front pairs. Like rabbits and kangaroos, these insects trade off the ability to run for the ability to hop. Unlike rabbits and kangaroos, however, most insects with long rear legs leap many times their length. Thus, one good jump may be sufficient for an insect to reach safety, especially because most predatory insects and spiders have limited vision.

BELOW LEFT This is a snout beetle. Although they can fly, snout beetles usually walk. The joints of this beetle's legs allow the legs to move primarily from side to side, but the hind legs have been rotated underneath the beetle's body, so their two dimensions are back and forth. BELOW RIGHT This insect lived in the tropical rain forest, where insects are often camouflaged to avoid being seen by the numerous predators that might eat it. Every part of this insect's exoskeleton looks like a leaf. The insect's left front leg is bent. Note that the lower part of this leg fits into the upper part such that the leg is prevented from wobbling. The insect's front legs have swung around so that they move at an acute angle to its body. Although the terms are not appropriate, you might think of insects as moving bending their knees as they swing their legs from the hip.

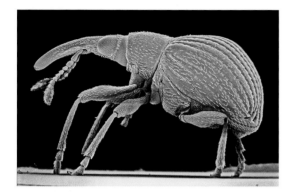 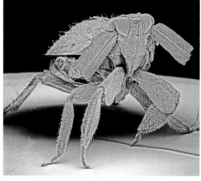

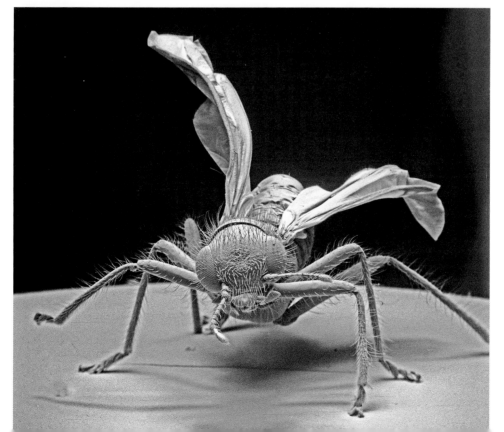

The six legs that protrude from the sides of this insect provide a sturdy stance. Six must be a good number, as there are more species of insects in the world than all the other species of animals and plants combined.

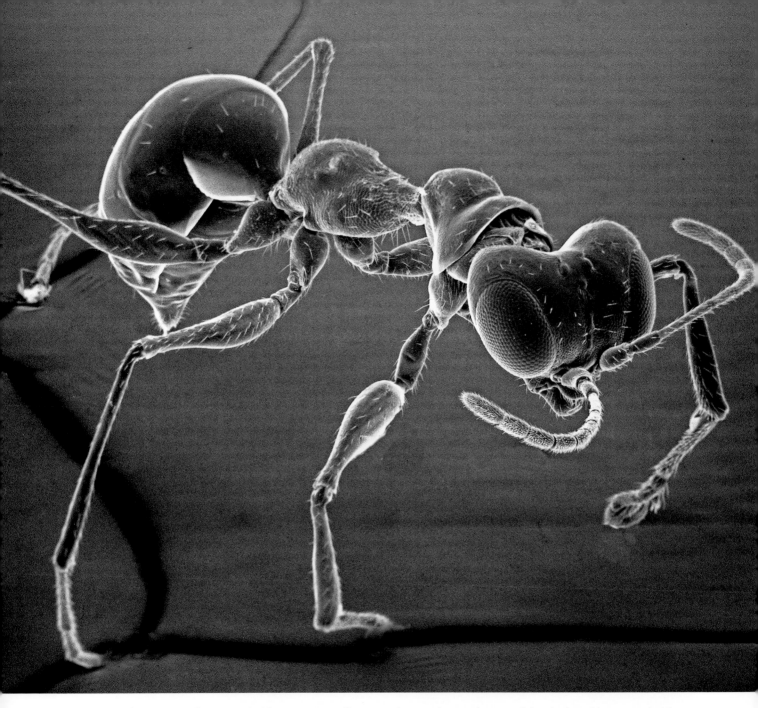

This species of tiny parasitoid wasp must walk or run wherever it goes, because it is wingless. Many parasitoid wasps lay their eggs in insect hosts. If these wasps had wings they would probably be a hindrance, because the wasp must be quick and agile in order to lay her eggs before a potential host harms her or escapes.

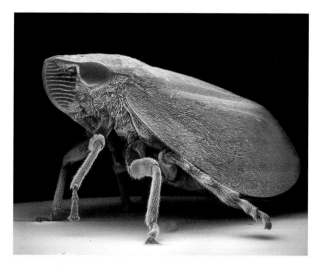

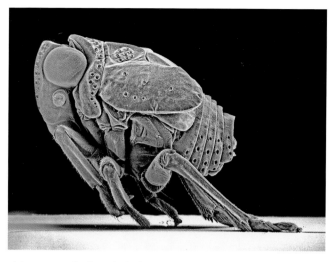

This is a leafhopper (Cicadellidae). You often see these little insects jumping around when you walk across your lawn or the grass in a park. The next time you see a leafhopper jump, consider how far it travels. For its size it would probably be equivalent to a kangaroo traveling the length of a football field in a single hop.

This strange-looking little hopper is sometimes common in fields in the Middle East. Spines on the large rear feet provide good footing to prevent the hopper from slipping as it leaps into the air.

Because they usually live in open grassland, grasshoppers are vulnerable to predation by birds, mammals, spiders, and insects. Aided by relatively good vision and hearing, grasshoppers avoid being caught and eaten by hopping away from danger. Some species take several hops and then disappear below the grass. Others open their wings and fly away after launching themselves with their rear legs. Many species have another defense; they regurgitate noxious chemicals.

A number of grasshopper species have two different lifestyles. When food is plentiful, they are solitary and colored to blend in with the grass. However, when conditions become difficult, for example, when there is a drought or when they become overcrowded, young grasshoppers gather together and become more colorful. They often eat toxic plants, which render them poisonous to predators. When they become adults, they fly off in giant swarms and we call them locusts.

Many insects and insect larvae live below the ground, where certain kinds of foods such as roots, mold, mites, and worms are plentiful and where they are safe

The hind legs of this beetle are for digging. They are larger than the front two pairs, and they are shaped something like shovels.

from many predators. These insects need to be expert at digging tunnels under the earth. Ants and termites use their mouthparts for digging. Other insects such as certain crickets and cicada nymphs dig with their powerful front legs. Although most kinds of beetles use their forelegs for digging, some species dig primarily with strong rear legs.

A number of insects walk or swim with their two hind pairs of legs and use their front pair for grasping prey. The most familiar of these insects is the praying mantis, but various kinds of insects also have strong front legs they employ to seize and hold their prey. One of the most interesting of these is the ambush bug. These insects have a thick, hard cuticle and, like most heavily armored insects, move relatively slowly and are able to fly only for short distances. As the name implies, ambush bugs tend to lie in wait, often on flowers, and seize unsuspecting little insects. Most species are small, but for their size these little bugs are exceptionally formidable. An ambush bug will successfully take on a larger insect or even a small spider.

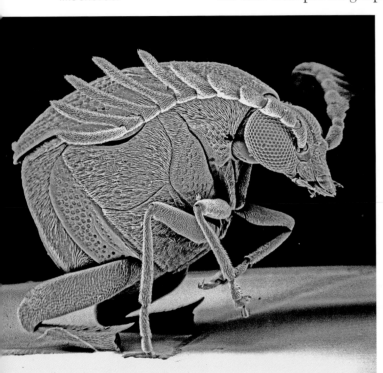

The legs of thrips end in bladder-like feet that the thrips can enlarge by pumping in hemolymph. Enlarged feet enable thrips to walk upside down on flower petals and other smooth surfaces. Many thrips feed on flowers, vegetables, grains, and fruit trees. Some species feed only on one species of plant, whereas others attack many kinds of plants including many crop plants. However, to some extent these interesting little insects have been given a bum

OPPOSITE TOP This grasshopper nymph looks much like an adult grasshopper except that it is small and has no wings. Since grasshopper nymphs are wingless, they depend on their hind legs to escape predators. OPPOSITE BOTTOM There are more species of beetles (Coleoptera) than of any other group (order) of insects. Although beetles have many different lifestyles, many species live underground. The powerful hind legs of this beetle are designed for digging.

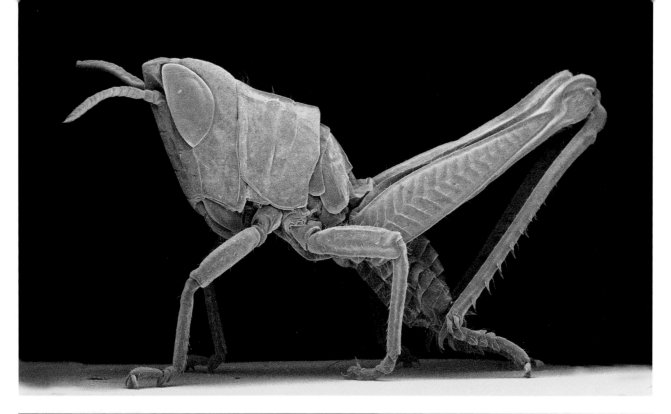

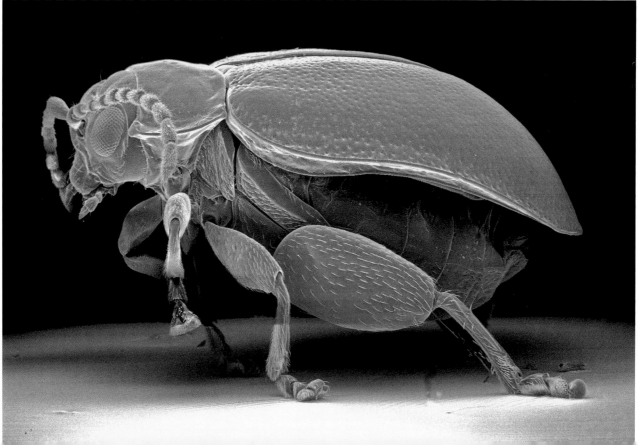

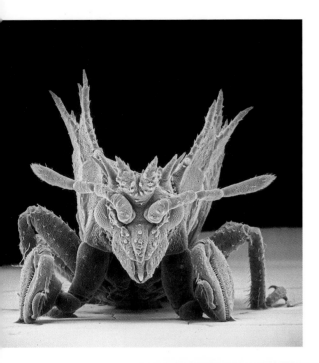

This ambush bug (Phymatinae) resembles a *Stegosaurus*, and its front limbs are reminiscent of the jaws of *Tyrannosaurus rex*. It is easy to see how most insects of similar size are no match for an ambush bug. They are so heavily armored that they move slowly and can hardly fly. However, their thick cuticle and prominent spines protect them when they struggle with their prey or are attacked by spiders or larger insects.

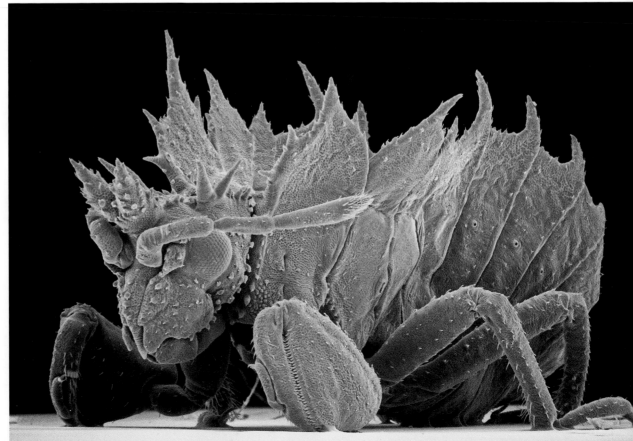

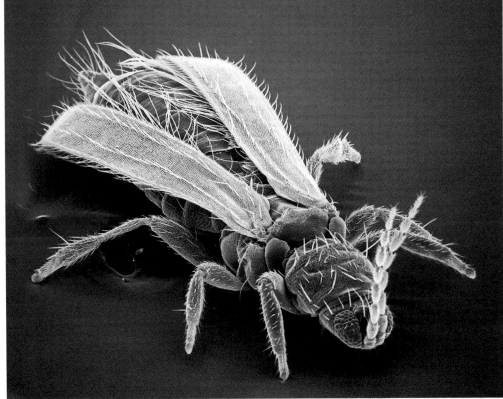

ABOVE Because many thousands of thrips can suddenly appear in fields during foul weather, they are sometimes called thunderflies. The feet of some thrips contain toxins that can irritate human skin. This isn't a problem with only a few thrips nearby, but when millions of thunderflies fill the air, it is wise to leave the area. RIGHT Unlike the feet of most insects, the rounded feet of this thrips are not clawed. When thrips pump hemolymph into their unique feet, these tiny insects are able to cling tenaciously to leaves and stems of the plants they live on.

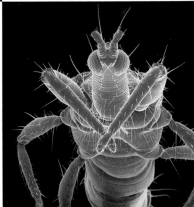

rap, as many species of thrips feed on fungi that can destroy crops and on pests including mites and other thrips species.

The so-called raptor feet of certain insects are used for seizing and holding prey, just as the feet of raptors—owls, hawks, and eagles—have talons for the same purpose. The raptor feet of insects are characterized by a single large, sharp, hooked claw that looks something like an old-fashioned ice hook. Although the raptor foot is highly effective in grabbing and holding prey, it is not very useful for walking or running on land. For example, all six legs of dragonflies have raptor feet. This enables dragonflies to grasp

In addition to the three pairs of thoracic legs, most caterpillars have five pairs of so-called prolegs, although there are species with one, two, three, or four pairs. This one has only four pairs of prolegs. The thoracic legs have a single claw, whereas each proleg has many regularly arranged tiny hooks that can enable the caterpillar to hold on to plants with incredible tenacity. Even in strong winds caterpillars don't lose their grip.

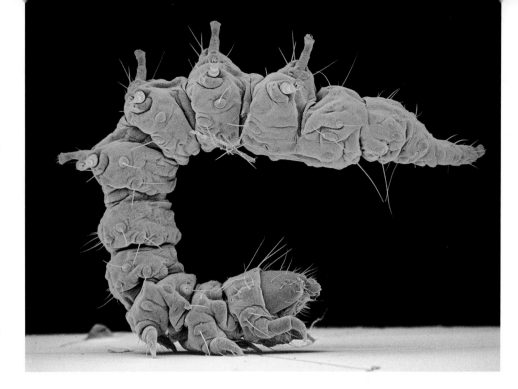

and hold prey and to hold on to stems of plants, but dragonflies cannot walk or run. Caterpillars have an extra set of legs called prolegs, located on their abdominal segments. The feet of prolegs have a ring of tiny hooks that can cling tenaciously to plants. If you try to remove a caterpillar from a stem or a leaf, it will hold on incredibly tightly, and if you let a large caterpillar walk on your hand and try to pull it off, you can feel the tiny hooks grasping your skin.

Caterpillars don't always turn into moths or butterflies. The larvae of sawflies, a group of primitive wasps, and scorpionflies, primitive insects that look something like delicate flies, look like the caterpillars of butterflies and moths but can be distinguished because they have more than five pairs of prolegs. Sawflies and scorpionflies belong to different groups (orders) of insects than butterflies and moths. Fossil evidence indicates that insects similar to scorpionflies were present long before butterflies, moths, and wasps appeared on the earth, and there is evidence that butterflies, moths, and wasps evolved from insects that resembled scorpionflies. Thus, larvae of butterflies and moths may have retained the ancestral caterpillar form of their scorpionfly-like ancestor.

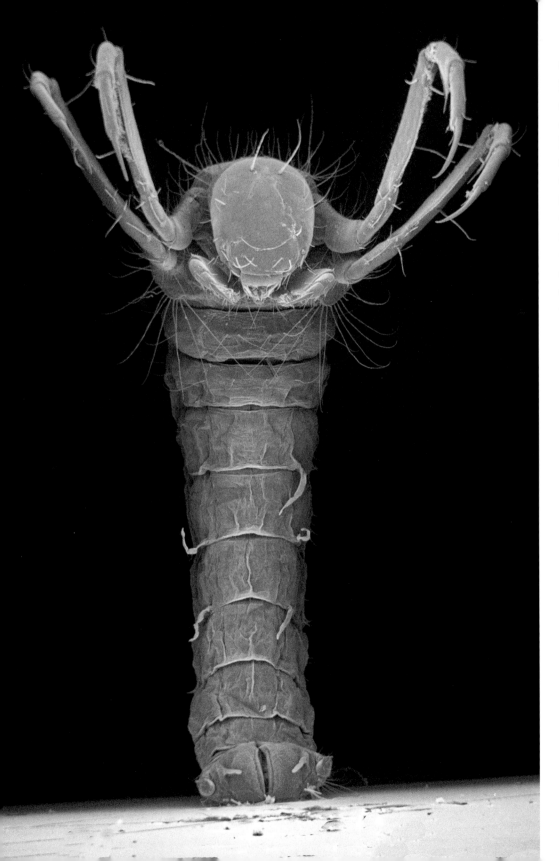

With their legs and long, sharp raptor feet outstretched, aquatic caddisfly larvae grab little insects and other arthropods. Most species of caddisflies live in lakes, streams, or rivers. They construct chambers made of sand or sticks. Each species builds a characteristic chamber (I removed the chamber from this caddisfly larva).

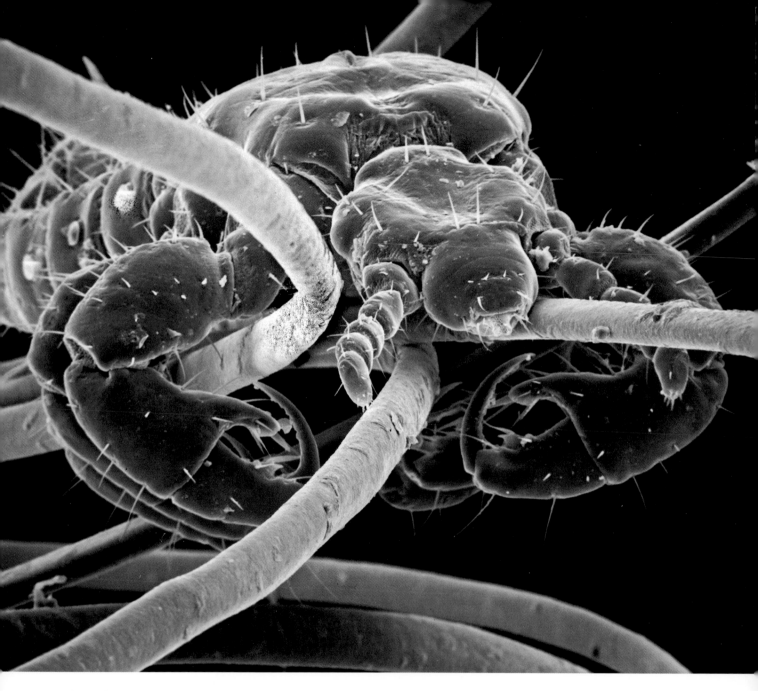

I placed this head louse on some human hair. The hooks on a louse's feet, which are shaped like metal bag clips, are ideal for grasping hairs. Lice spend their entire life on the same individual host unless they are transferred to another host by direct contact.

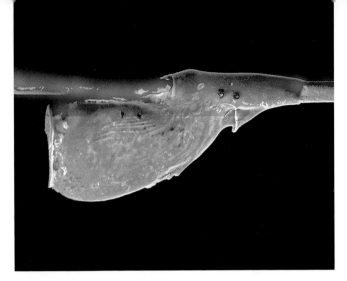

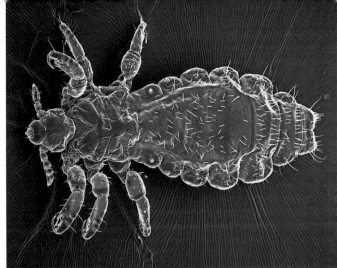

This is an empty egg of a head louse. It's called a nit. After the louse nymph hatches, the empty nit remains attached to a hair. Female human head lice produce a gluey substance for cementing their eggs to hairs. Females of many other kinds of insects also secrete gluey substances to attach their eggs to plants.

This is a human head louse (*Pediculus humanus capitis*). Head lice are wingless and can hardly walk. They are flat insects with a thick, leathery exoskeleton that protects them when their host grooms or scratches. As you might expect, fleas and ticks, which are also arthropod ectoparasites, are flat and have leather-like exoskeletons.

The claw-like hooks on the feet of lice grasp the hairs or feathers of the mammals or birds that lice live on. Male lice also employ their claws, as well as their antennae, to grasp females when they mate.

Body lice are common where people live in close quarters and do not bathe. During World War I these insects were endemic among soldiers in trenches. Battles were won and lost depending on typhus, a disease that was sometimes spread by body lice. The advent of DDT and other insecticides greatly reduced the problem in World War II.

Human head lice are common in young children because they acquire lice through contact with their schoolmates. These lice do not carry disease-causing organisms, but they can cause itching that leads to sores. There are several anti-louse shampoos that do not contain potentially dangerous insecticides. However, lice can become resistant to these shampoos, and because their eggs, which take a week to ten days to hatch, are not readily killed by these shampoos, the treatment needs to be repeated in two weeks.

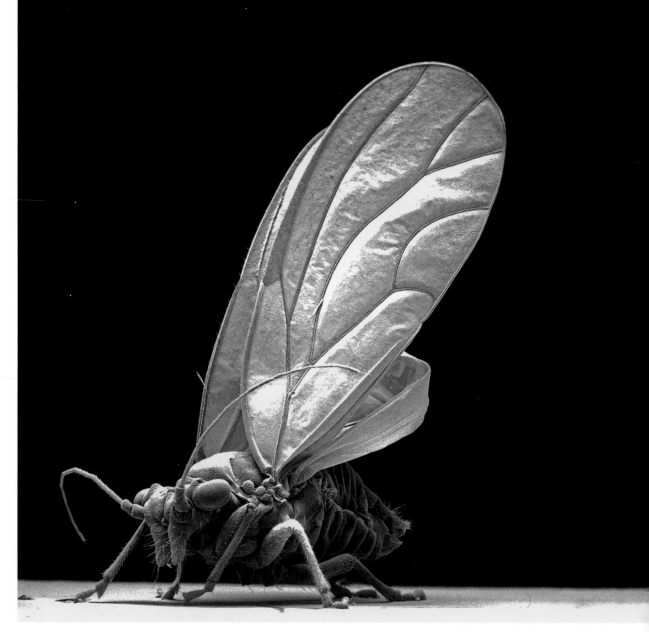

The veins that can be seen in the wings of this little book louse (Psocoptera) resemble leaf veins. Like leaf veins, they provide support. As the number and arrangement of wing veins is characteristic for each group of insects, the configuration of wing veins is one of the traits that are used to identify insects.

10 | wings

INSECTS are the only invertebrates that have wings. Insect wings are so prominent that most orders of insects are named for their wings. The Latin word for wing is *ptera*. The order that bees, wasps, and ants belong to is called Hymenoptera, which means membrane wings. Butterflies and moths are Lepidoptera, which means scale wings. Flies are Diptera, which means two wings, and so on.

Unlike the wings of birds and bats, insect wings are not modified limbs but outgrowths of the exoskeleton. Each side of the wing has an exoskeleton, and the two sides of the wing are pressed tightly together. Veins, which somewhat resemble the veins of a leaf, characterize insect wings. Like the veins of leaves, the veins of insect wings provide support for the thin, delicate wings. Large veins contain nerves and are connected to the body cavity such that insects can force hemolymph through them. This is important because when insects emerge from their pupa case their wings are crimped. Insects expand and straighten their wings by forcing hemolymph through their wing veins.

The flight muscles of insects are in their thorax. Birds and bats are somewhat similar in that their powerful flight muscles are in their breasts. Having the flight muscles inside their body rather than in the wings makes sense for insects as well as birds and bats, because wings need to be light and muscles are heavy. In some insects flight muscles are attached to their wings. However, in most insects flight muscles are attached to the upper and lower sclerites of their thorax, and the

Lace bugs (Tingidae) get their name from their lace-like wings. Not only do the veins strengthen the insects' wings, just as veins strengthen leaves, but they also help many kinds of insects avoid detection because their wings resemble leaves. The wings of lace bugs blend in with the underside of the leaves where they live. Unlike most true bugs, female lace bugs care for their young.

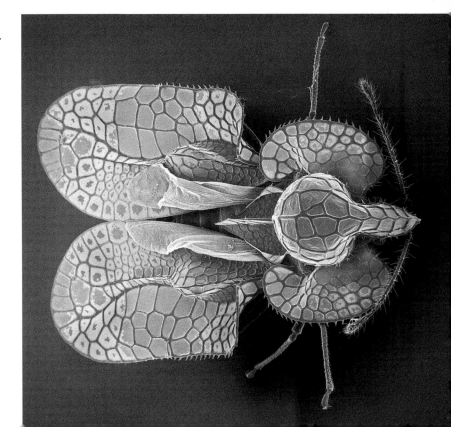

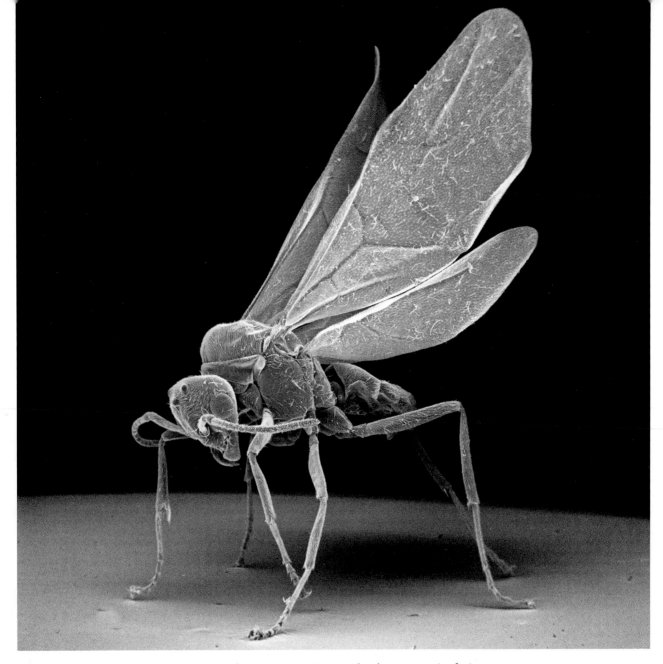

Like most insects, this wasp has two pairs of wings. In most insects that have two pair of wings, the forewings and hind wings are joined together with hooks, hairs, or in other ways such that when the animal flies, the two wings on one side beat in unison.

lower sclerite acts like a fulcrum. Muscles attach such that the wings are powered upward when the muscles contract to move these sclerites closer to each other. Contractions of muscles that are parallel to the long axis of the insect's body supply the force for the downstroke.

The manner that they use their wings for flying varies among insects. Some, for example dragonflies, can beat each of their wings independently. In other types of insects including many true bugs, butterflies, and bees the forewings and hind wings are attached during flight such that the wings on one side beat in unison. In beetles, many true bugs, and grasshoppers the forewings are used for lift and steering. Only the rear wings beat. Most all insects also glide intermittently when in flight. Gliding saves energy and helps insects to avoid overheating. One of the most remarkable things about insect flight is that many insects including dragonflies, many bees, flies, and moths called sphinx moths can alter their wing beat so that they can fly backward or hover.

This wasp looks like it has big abs. Flight muscles, which take up most of the volume of its thorax, are connected to the upper and lower sclerites. The lower sclerite acts like a fulcrum such that when the flight muscles contract, the wings move up. Longitudinal muscles in the thorax contract to move the wings down.

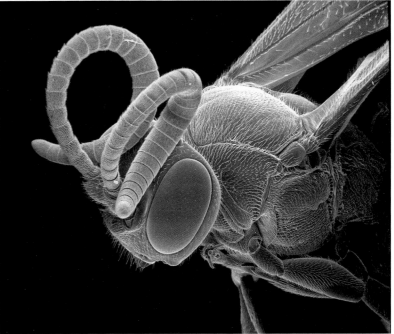

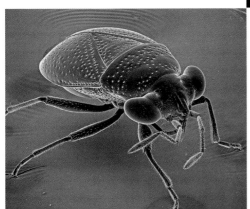

The forewings (hemelytra) of this hemipteran also protect the underlying hind wings and abdomen.

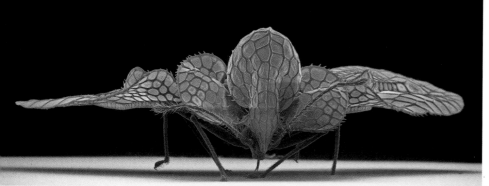

The hemelytra of lace bugs are used like the wings of fixed-wing airplanes. This lace bug even looks a bit like an airplane.

Like most beetles, this one is protected by a thick, relatively impenetrable exoskeleton. The tough, inflexible forewings or elytra of beetles protect their abdomen and delicate hind wings, which are neatly folded underneath the elytra. When they are attacked, some species of beetles, for instance ladybugs, pull their legs and antennae under their elytra for protection. During flight, beetles swing their elytra perpendicular to their body, where they are employed for lift and turning.

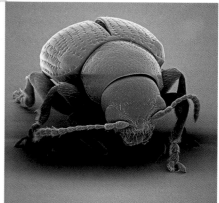

The forewings of many insects are far thicker and harder than the hind wings. In these insects the forewings are involved both in flying and in protecting the underlying hind wings and abdomen. It is important that the hind wings and abdomen are protected, because the hind wings are delicate and the exoskeleton of the abdomen of most insects is softer than that of the head and thorax and thus more vulnerable to being pierced by predators.

When insects with hard forewings fly, the forewings extend perpendicular to the insect's body. Although they do not beat, the insect uses them to steer and glide. Thus, in these insects, the forewings function something like the wings of an airplane, and the hind wings act something like the wings of a bird. The forewings of beetles, called elytra, are especially hard and tough. Those of many grasshoppers, cockroaches, and true bugs are often referred to as hemelytra, because the portion of the wings nearest the thorax is hard and the outer part of the wing is membranous.

Flies have only forewings. Their hind wings are modified into knob-shaped

Although many kinds of flies are fast and agile in the air, others fly weakly. This is a fungus gnat (Sciaridae). I did my PhD work on these animals. When I first considered working on this gnat, I went to the University of Chicago's greenhouse, because my adviser had told me that sciarids could be found there. I didn't see any. When I told my adviser about my failed hunt, he went to the greenhouse with me and pointed out many sciarids. Fungus gnats are so small and fly so feebly that I didn't consider that they could be flies. My experience with flies had primarily been with house flies, which are many times larger and considerably more robust and adept in the air.

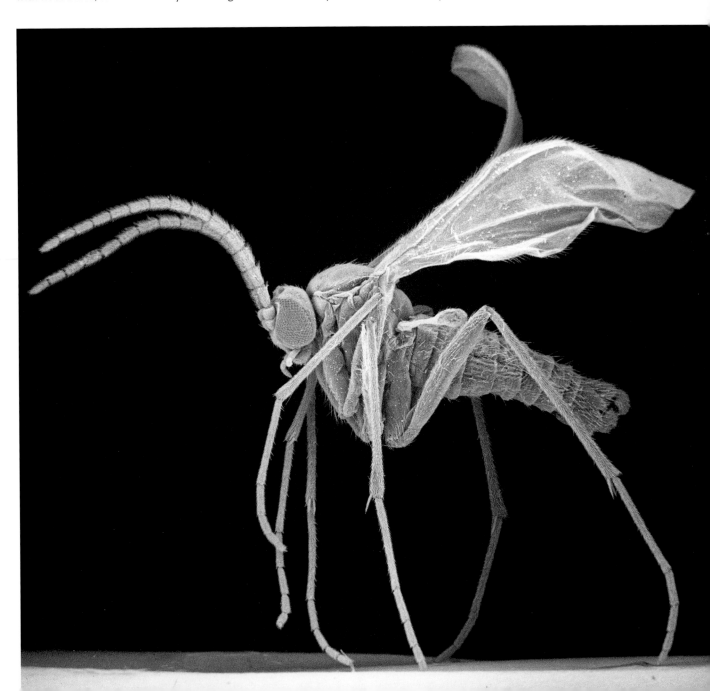

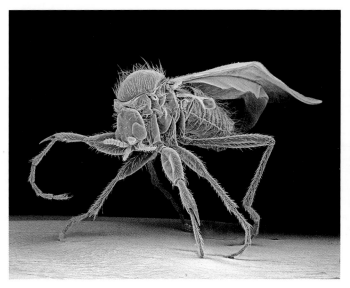 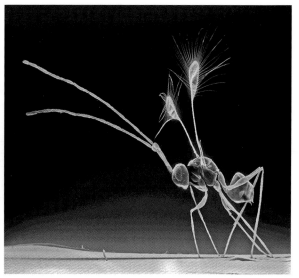

LEFT This fly is called a midge (Chironomidae). Note the little paddle-shaped halters behind and below the fly's front wings and on the fungus gnat on page 101. In flight, halters spin around and act like gyroscopes. The halters enable the fly to sense its orientation with respect to the earth's surface, which helps the fly to keep upright. On a cloudy day (or in your home), when there is no polarized light, flies depend on halters to help them keep their balance in the air. Instruments that measure the angle of airplanes with respect to the surface of the earth also use gyroscopes. RIGHT Some species of fairyflies live in water. They even mate and lay their eggs underwater. Aquatic insects that swim generally use their back pair of legs as paddles. Fairyflies are unusual because they employ their wings as paddles for swimming.

organs called halters, which act as gyroscopes that enable flies to determine their orientation with respect to the ground. Having only two wings isn't a handicap for many flies, because their halters enable them to perform amazing acrobatics. Consider the house fly. It can fly up to the top of a room, roll 180 degrees, and land upside down on the ceiling. Wow!

Fairyflies (Mymaridae) are minute wasps. If your eyesight is good and a dark-colored fairyfly is on a white background, you may be able to see it as the smallest of specks. The physics of swimming and flying are different for minute animals than for larger ones, because small objects have less momentum. Observe a baby fish only a quarter of an inch long. The fish does not glide but appears as though it is swimming in molasses. It is the same with flying. Very tiny insects must beat their wings a thousand times a second or more because they

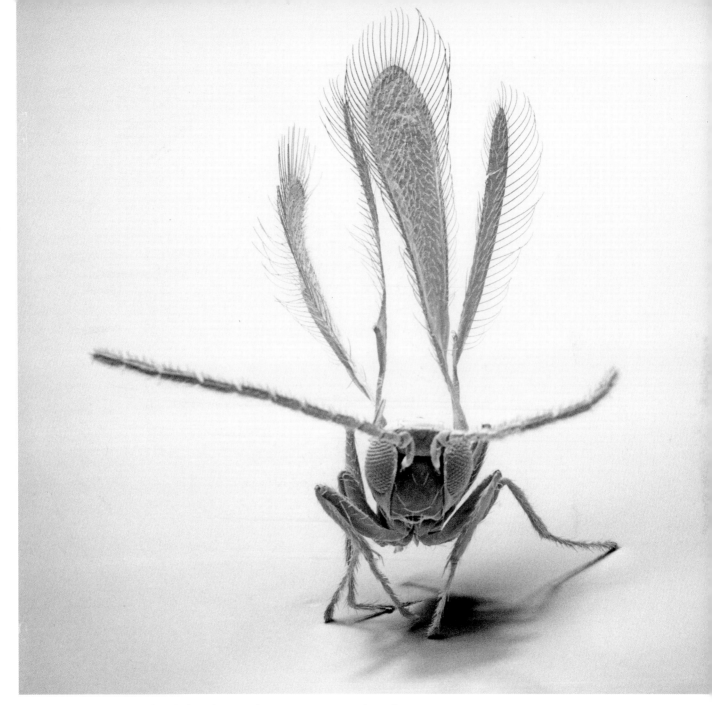

The unusual wings of this fairyfly have hairs at their tip. Most insects beat their wings at frequencies of a few to a couple of hundred times a second, but the wings of certain minute insects like fairyflies beat more than a thousand times a second.

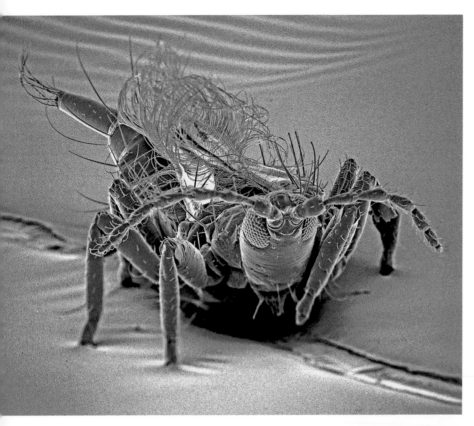

The order that thrips belong to is called Thysanoptera, which means fringed wings. The fringes are numerous hairs. These fringed wings, like those of fairyflies, are designed to beat rapidly. If this is a female thrips, all her eggs will develop into females provided that they have been fertilized. Any egg that has not been fertilized will become a male. This is not unique to thrips. For example, fertilized eggs of bees, wasps, and ants become females, and unfertilized eggs develop into males. Some kinds of thrips are parthenogenetic, which means that all the offspring are identical to one another and to their mother. Parthenogenesis occurs in other insects as well. In fact, males have never been found in a number of insect species.

This is a book louse (Psocoptera). Most book lice are wingless, but they still travel widely. They are one of many kinds of insects that have been disseminated by humans; we inadvertently transport insects in our cloths, suitcases, cars, trucks, trains, airplanes, and boats all over the world. Consider that thousands of airplanes and boats carry all manner of cargo internationally every day. As a result, many insect species in the United States are the same as those in other parts of the world. Some of these arrived by boat (such as most species of termites) before there were airplanes.

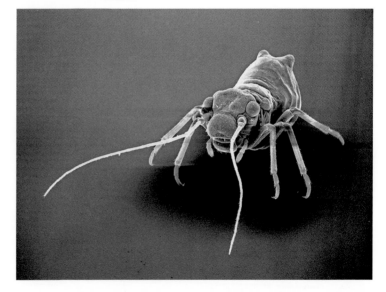

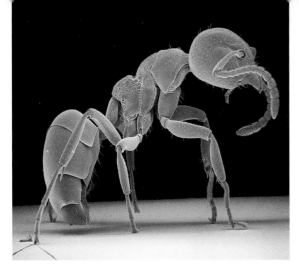
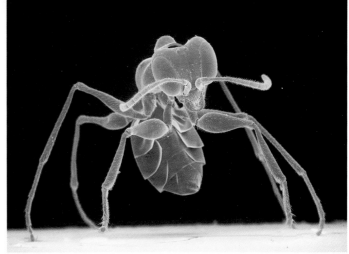

LEFT Worker ants like this one are wingless, sterile females. The lifestyle of a number of insects does not require wings. Ants, for example, live underground. Wings might be awkward and slow them down as they traverse the tunnels in their colony. However, if the colony becomes too crowded, winged male and female ants develop. They fly off, form swarms, mate, and establish new colonies. RIGHT This is a wingless wasp. There are many species of wasps that are so small they can hardly be seen with the naked eye, and a lot of them are wingless. As mentioned in the previous chapter, legs are more useful than wings for the quick, agile escape maneuvers these tiny wasps must be able to make in order to survive.

do not glide between beats. As nerves cannot send impulses fast enough, the nerves to the wings of fairyflies send an impulse precisely on every few beats, and the wings vibrate something like the strings of a piano such that a signal from a nerve comes at the precise time to keeps the wings flapping. The wings of these minute fliers are designed differently from wings of larger insects. Long hairs characterize their wing tips.Charles Darwin observed that some insects that lived on small islands in the Atlantic Ocean were the same species as insects in South America, except that they were wingless. He concluded correctly that the island insects had lost their wings over years of evolution because it is not of selective advantage for an insect to fly on a small island—the wind is likely to blow it out to sea.

The most primitive insects are wingless, suggesting that insects existed for millions of years before they evolved wings. This is substantiated by fossil evidence. There are also wingless species of flies and bees, and in a few species of beetles, butterflies, and moths the females are wingless.

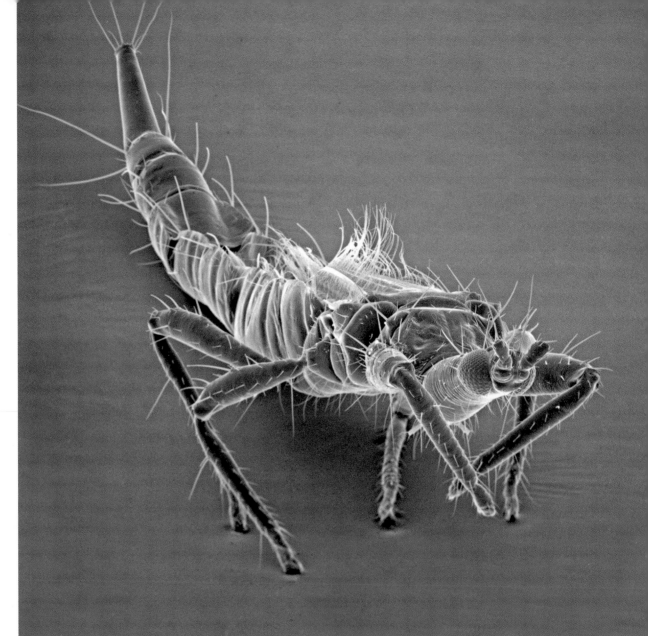

Thrips, like this one, can launch themselves into the air by rapidly moving the segments of their abdomen on one another. This method of escape may be quicker than flying, as it takes some time to prepare for flight.

11 | abdomen

THE ABDOMEN of insects contains the reproductive organs as well as most of the digestive tract and respiratory system. In many adult insects there are no obvious structures involved in copulation and laying eggs, because they are withdrawn when they are not in use.

In most insects the exoskeleton of the abdomen is softer and more flexible than that of the head and thorax, because it needs to enlarge in order to accommodate food and/or growing eggs. The upper and lower sclerites are often relatively flexible and connected by soft chitin that facilitates expansion. In large active insects the abdominal sclerites move when the insect breathes. Instead of lungs, insects have a branching network of tubes called trachea, which connect to openings called spiracles in the sides of the abdomen. Diffusion of air into the trachea is sufficient for small insects, but large insects breathe by moving the upper and lower sclerites of the abdomen.

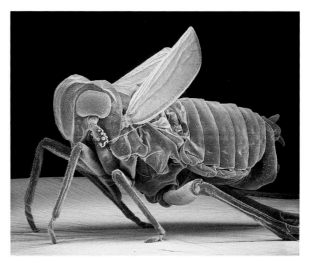

Some insects can curl their abdomen up above their thorax or move it from side to side. The ability of an insect to bend its abdomen can be important for a number of functions, most notably escaping predation, moving in tight situations, mating, and laying eggs. Males that mate by mounting females bend their abdomen when they mate. Some insects, such as damselflies, have an elongated abdomen that undergoes a complex series of twists during courtship, mating, and egg laying. Many insects use ovipositors to

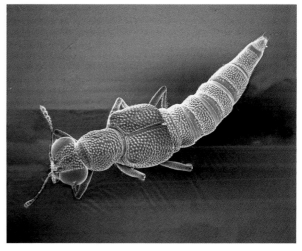

TOP In this little insect the upper sclerites of the abdomen overlap the lower sclerites. Soft, leather-like chitin connects them so that the abdomen can expand when the insect eats or when eggs grow. BOTTOM The elytra and underlying folded hind wings cover only the front of a rove beetle's abdomen. This allows these beetles to bend their abdomens, unlike most beetles. When rove beetles fly, they lift their small elytra and unfold their hind wings.

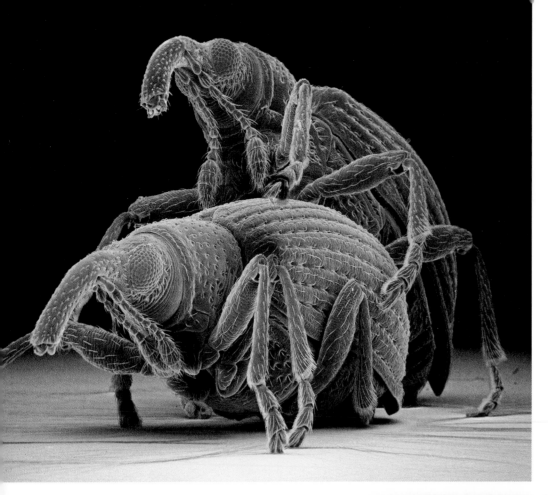

Insects take various positions when they mate. Some mate back-to-back. In other insects the male mounts the female, and there are a number of other positions depending on the insect species.

The claspers that can be seen at the end of the abdomen on this fungus gnat (Sciaridae) are designed to grasp and hold a mate. Gnats mate back-to-back. Although the couple often runs around, the male's clappers are so well designed for their purpose that the female cannot disengage until the male releases her.

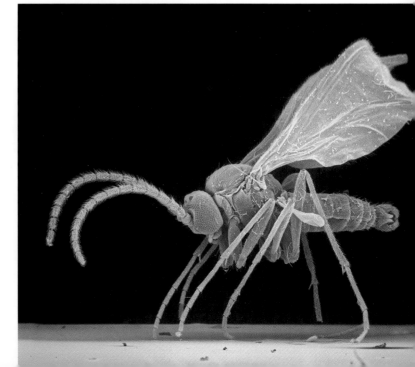

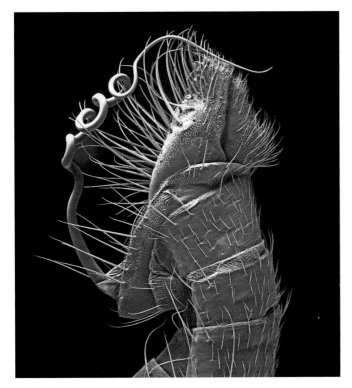

The long, curvaceous structure at the end of this parasitoid wasp's abdomen is an ovipositor. Some species of wasps trail long, straight ovipositors, whereas others, like this wasp, have a coil ovipositor that fits under their abdomen. When the appropriate host is found, the wasp skillfully inserts her ovipositor into the host.

The ovipositor of a wasp. Aphid colonies are attacked by some species of small parasitoid wasps. The female wasp adroitly skips from aphid to aphid inserting her ovipositor and depositing one egg in each host. As it matures, each wasp larva dines on its own little aphid.

deposit their eggs. Movement of their abdomen provides the force to thrust the ovipositor into the earth, a plant, wood, or an animal. Although grasshoppers lack ovipositors, they lay their eggs under the earth. Movements of their abdomen un-earth holes for their eggs.

In most mammals sperm survive in the female genital tract for hours to days. Thus, in order to fertilize the eggs, mammals need to mate at around the time when the female ovulates. Insects are different. After mating, female insects store sperm in abdominal chambers, where they usually remain viable for the life

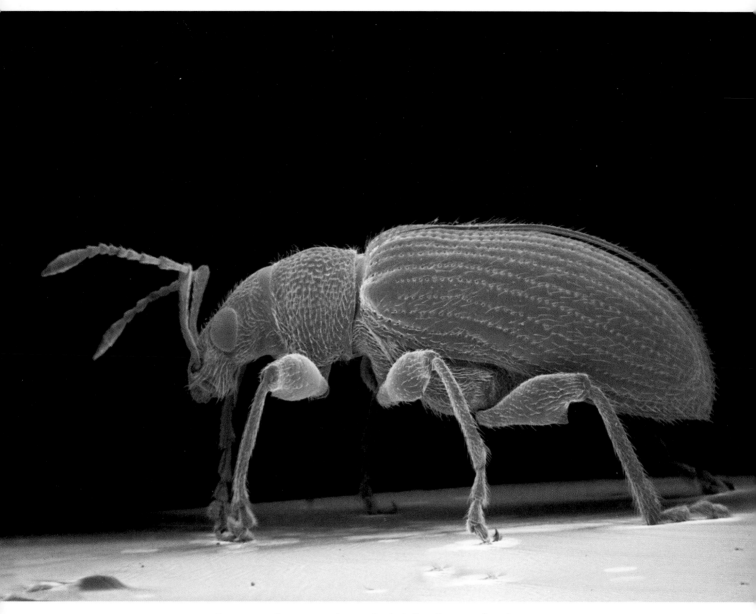

Insects need to mate only once in their lives because females store sperm and fertilize their eggs when they are laid. In most insects, like this snout beetle, the copulatory organs and ovipositors remain internal except when the insect is mating or laying eggs.

of the insect. This is advantageous because a female insect may need considerable time after mating to locate a suitable place to lay her eggs.

Sperm storage is not unique to insects. Some species of tortoises store sperm for years, as there may be few individuals in an area, and, as tortoises don't cover a lot of ground, males and females may only rarely come into contact. The ability to store sperm ensures that sperm will always be available when needed. Songbirds also store sperm to ensure that their eggs are fertilized even if a male is not present. Some species of bats store sperm because they congregate and mate before their winter hibernation, but have a short gestation period and don't give birth until the spring. Sperm remain in the female bat for several months before her eggs are fertilized. Certain other mammals have a different method to extend the time between mating and giving birth. Many kinds of seals leave the sea and congregate on land only once a year. Thus, they need to give birth to babies previously conceived, come into heat, and mate within few weeks. Rather than store sperm, the females store embryos: seal eggs are fertilized soon after they mate, but embryos remain

in the uterus in a dormant state for four or five months so that the gestation period of seven to eight months will coincide with when the female seals come ashore the following year.

In order to mate successfully, a male insect generally needs to grasp his mate tightly so that she cannot walk or fly away. Males use a number of methods to hold on to their mate. In many species males hold females with forceps-like structures called claspers located on the back of the male's abdomen. Claspers hold the female so tightly that the couple stays attached even if the female tries to walk or fly away or the pair falls off a plant. In some insect species the male's genitalia are designed such that they will fit only into the genitalia of a female of his species. This presumably prevents males from mating with closely related species.

You may have observed that many insects appear to be mating and question why it takes them so long. If fact, the pair may have already mated. Holding on to your mate is a strategy to help ensure paternity, as it prevents other males from mating with this female. Ensuring paternity is essential to natural selection; males that fail to reproduce don't pass their genes to

the next generation. Male insects, therefore, as well as most other male animals, have developed numerous paternity-ensuring mating strategies. Whole books have been written about this. Another mating strategy employed by some insects is to remove another male's sperm from the genital tract of a female who has previously mated before mating with her. The penis of dragonflies is specialized for this purpose.

A group of wasps called ichneumon flies (Ichneumonoidea) have some of the longest ovipositors. Many ichneumons deposit their eggs inside beetle larvae that live in decaying wood. In order to locate beetle larvae, the female of some species of ichneumons walks on a decaying log. She then accomplishes the amazing feat of sensing the larvae in the wood, penetrating a distance of an inch or more into the wood with her ovipositor, piercing the larvae, and depositing her eggs.

Bees and wasps that sting are sterile females. The stinger is a modified ovipositor through which toxins are injected. The great success of honeybees and other

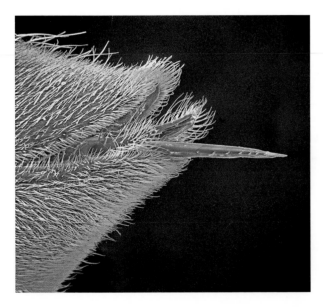

colonial insects owes to their hard and skillful cooperative work and willingness to sacrifice their lives for the good of the colony. Honeybees sacrifice their life when they sting because the rear of the abdomen detaches with their stinger. Although the sting of a worker honeybee or even several is not serious for most people, those who are allergic to the bee's toxin can go into anaphylactic shock. In fact, honeybee stings kill more people in the United States than spiders, scorpions, and snakes combined. The stinger is a remarkable structure. Unlike the stinger of wasps, the honeybee stinger is barbed so that it detaches along with the rear of the abdomen when the bee stings. Muscles in the detached portion of the abdomen pump toxin into

The business end of the honeybee (*Apis* sp.) worker. The tiny barbs that are visible on the stinger in this micrograph ensure that the stinger and rear of the abdomen detach and remain in the intruder. The stinging apparatus continues to pump poison and releases alarm pheromones that attract other bees. If you are stung by a honeybee, remove the stinging structure carefully and leave the area. Carry an epinephrine injector if you are allergic to bee stings.

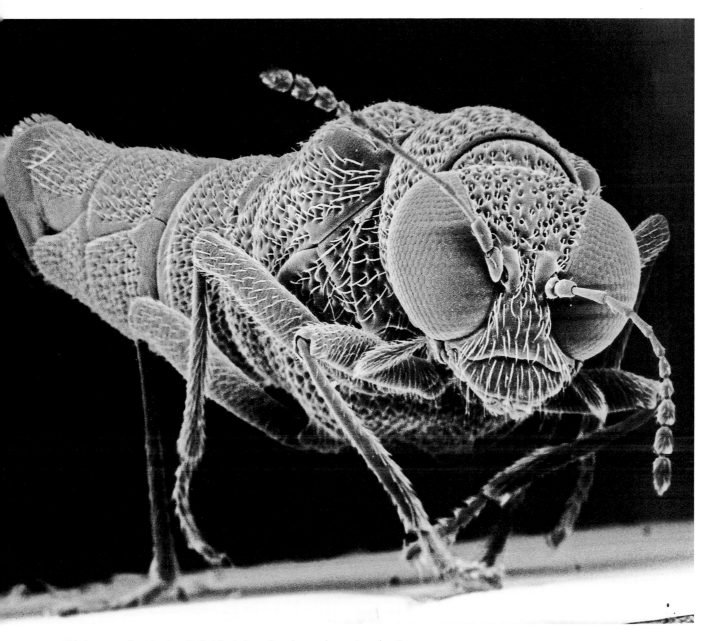

This is a rove beetle (Staphylinidae). Rove beetles and certain other insects spray toxins through the end of their abdomen. A rove beetle can turn its abdomen in order to direct a spray of toxins. To spray a predator in front of it, a rove beetle will lift its abdomen over its head.

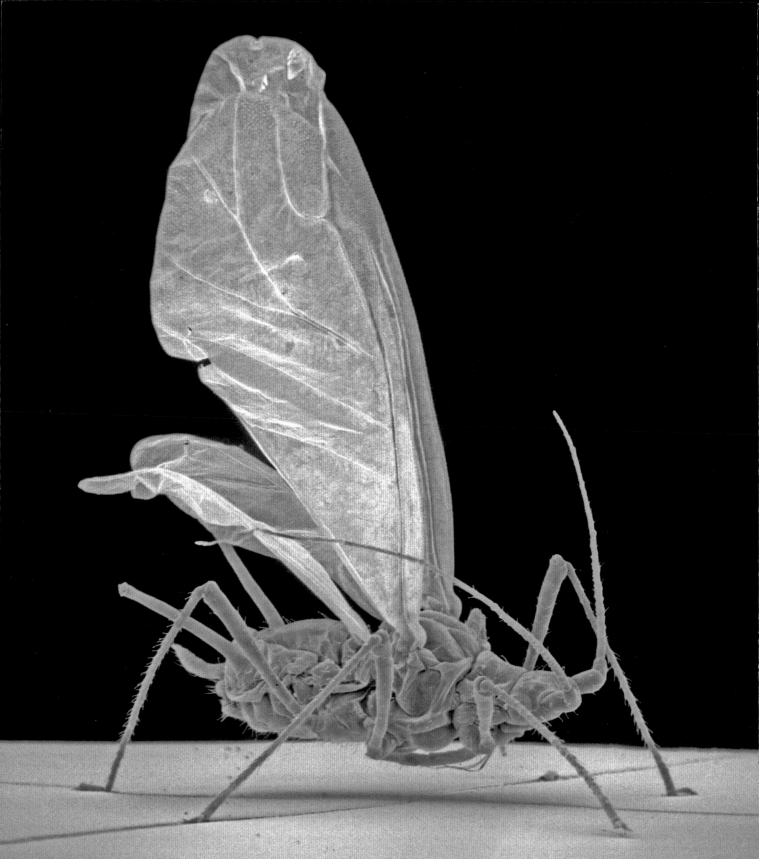

the intruder. In addition, the stinging apparatus releases pheromones that signal other workers in the colony that an intruder is nearby. More workers from the hive or area then quickly attack.

Numerous insects secrete toxic chemicals for defense. Different kinds of insects secrete toxins from different places. Grasshoppers regurgitate defensive toxic chemicals through their mouth. Other insects secrete defensive chemicals from their thorax and legs.

Aphids are tiny soft-bodied insects that usually have a pair of tubes called cornicles on the back of their abdomen. Cornicles are defensive weapons used to combat parasitoid wasps and other predators. To fight off these predators, aphids secrete fluid droplets through their cornicles. When the fluid contacts the air, it changes into a thick, viscous wax that immobilizes predators. In some species of aphids toxic chemicals and pheromones that signal danger to other aphids are mixed with the sticky fluid. This aphid defense appears to be reasonably effective, as dead predatory wasps can often be found stuck to the stems of plants in aphid colonies.

The young of a number of insects develop in ponds, lakes, and streams. In order to breathe, the larvae of some species have abdominal gills. Aquatic larvae that look like adults are called naiads. Mayfly naiads, which spend most of their time under rocks in clear lakes and streams, have seven pair of gills on the sides

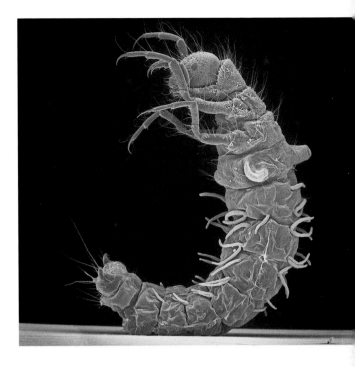

The wormlike structures on the abdomen of this aquatic caddisfly naiad are gills. Many insects and insect larvae that live in water have gills. Other kinds of insects breathe through snorkel-like tubes or carry air bubbles.

OPPOSITE Two backward-pointing, tube-like cornicles can be seen on the back of this aphid's abdomen. Aphids are relatively defenseless little insects. Many are wingless, and those with wings like this one fly slowly. Aphids also walk slowly, and their soft cuticle is relatively easy to penetrate. A waxy, poisonous substance they can secrete from their cornicles provides them with some protection. In addition, aphids can secrete alarm pheromones from their cornicles. Most animals that live in groups have a way to warn others of danger. With mammals and birds the alarm is a call. Because scents are so paramount to insects, it is not surprising that aphids, as well as many other kinds of insects, warn others of their species by secreting alarm pheromones.

The furculum of this springtail can be seen extending from its abdomen. This is the position of the furculum when the animal has sprung into the air.

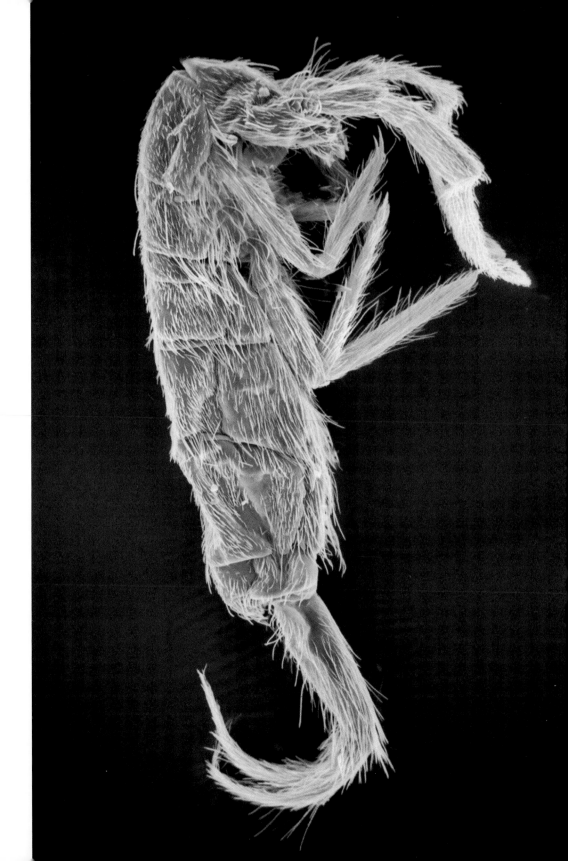

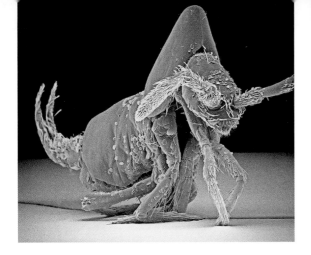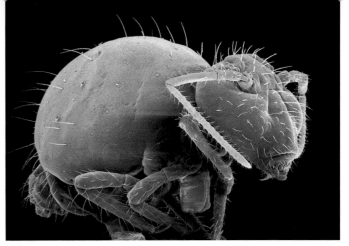

of their abdomen. These larvae are an indicator of pollution. It may be not so much that the adult females lay their eggs in unpolluted water, but rather when eggs are laid in polluted water the larvae do not survive. Mayflies may eat tiny animals and thus concentrate toxins that are in these animals. Although mayfly naiads live one to three years as larvae, in polluted waters most are probably poisoned and die along the way. Damselfly naiads have three gills on the back of their abdomen. Unlike mayflies, most species are not particularly sensitive to pollution and generally live in ponds. The gills of dragonfly naiads are not visible, because they are located inside the digestive tract in the abdomen. Dragonfly naiads breathe by taking in water as they expand and contract their abdomen. When threatened, a dragonfly naiad can expel water rapidly from its anus to propel itself away from danger.

Springtails are minute six-legged animals that used to be considered insects but are now thought to be a separate group of hexapods. Although they are common from the frozen north to the tropics, they are tiny and thus usually not noticed. Springtails are wingless and therefore usually travel by walking on their legs. However, they have a unique mechanism that enables them to escape danger by springing ten to twenty times their height. Underneath their abdomen is a unique forked structure called a furculum that is hinged at the back and can open rapidly to catapult the springtail into the air, hence their name. You may have seen thousands of specks dancing around on the surface of a pond, tidal pool, or on top of the snow, or minute objects bouncing up as you step in the grass. These are probably springtails.

LEFT This odd-looking creature is a springtail (Collembola). The furculum has swung out and can be seen behind the abdomen of this springtail. RIGHT In addition to the furculum, globular springtails have a tube-like structure under their body that emanates from the first segment of their abdomen. The structure, called the collophore, can be seen in this micrograph between the foremost and middle legs. The function of this structure is debatable; there is speculation that it takes up water or helps the animal gain traction.

SUGGESTED READING

FIELD GUIDES

E. Eaton and K. Kaufman. *Kaufman Field Guide to Insects of North America*.
New York: Houghton Mifflin Company, 2007.

> *In my opinion this is the best insect field guide. Like most good field guides of birds, trees, etcetera, this book features a dozen or more pictures on the same page. Most other insect field guides have only one insect per page. With over two thousand illustrations you can find the common insects. When you have identified an insect, you can almost always find more information by searching the scientific or common name on the Web.*

GENERAL BOOKS ABOUT INSECTS

C. O'Toole. *Firefly Encyclopedia of Insects and Spiders*. Toronto:
Firefly Books Ltd., 2002.

> *This interesting book explains most things about the lives of insects and spiders.*

W. Linsenmaier. *Insects of the World*. Toronto: McGraw-Hill Book
Company, 1972.

> *This older book is still available. Although there are many new observations about insects, most things haven't changed. Like the* Firefly Encyclopedia, *it covers the basics of insect life.*

P. Pesson. *The World of Insects*. Toronto: McGraw-Hill Book Company, 1959.
Although this book is no longer in print, I found it in a relatively small library.
It is well written and has a lot of good information.

TEXTBOOKS

P. J. Gullan and P. S. Cranston. *The Insects*. Malden, MA: Blackwell
Publishers, 2005.
Like other entomology textbooks, this book goes into subjects, such as
insect organ systems, that are not usually covered in general books
about insects.

THE WEB

The Web is very useful for identifying insects and learning about many aspects of
their lives. Two of the Web sites I like are Texas A&M's Field Guide to Common
Texas Insects (insects.tamu.edu/fieldguide/) and BugGuide (bugguide.net).

YouTube
Many aspects of the lives of insects — such as the sounds of grasshoppers or
how ants build their underground homes — can best be appreciated in videos.

Warning
Many people who enjoy collecting and photographing insects put things on the
Web. They are not always accurate.